LAKE
SAMMAMISH
THROUGH TIME

KATE NAVARRA THIBODEAU

AMERICA
THROUGH TIME®
ADDING COLOR TO AMERICAN HISTORY

This book is dedicated to my children:
I hope you learn to see the importance of the history all around you

AMERICA THROUGH TIME is an imprint of Fonthill Media LLC

First published 2015

Copyright © Kate Navarra Thibodeau 2015

ISBN 978-1-62545-063-0

Typeset in Mrs Eaves XL Serif Narrow
Printed in the United States of America

Published by Arcadia Publishing by arrangement with Fonthill Media LLC

For all general information, please contact Arcadia Publishing:
Telephone 843-853-2070
Fax 843-853-0044
E-mail sales@arcadiapublishing.com
For customer service and orders:
Toll-Free 1-888-313-2665

Visit us on the internet at www.arcadiapublishing.com

INTRODUCTION

Lake Sammamish is a freshwater lake seven miles long and one and a half miles wide located east of Seattle, Washington. To the north of the lake is the city of Redmond, where Lake Sammamish drains into Lake Washington via the Sammamish River, and to the south is the city of Issaquah, where the lake is fed by the Issaquah Creek. To the west is the city of Bellevue and to the east is the city of Sammamish.

The shores of the lake have been home to many, from the first residents, the Sammamish Native Americans, to the current residents of Issaquah, Bellevue, Sammamish and Redmond. When settlers began to move to the area in the late 1800s, the Native Americans were already very familiar with the landscape. The Sammamish were a band of the Duwamish Native American tribe who had regular camps along the lake. They spent summers fishing, hunting and harvesting berries.

Timber companies like the Donnelly Mill, Campbell Lumber Company, the Lake Sammamish Shingle Mill, and the Monohon Mill, realized the potential for development along Lake Sammamish. Logging and milling on the eastside of Seattle began slowly during the 1880s. The Great Fire of 1889 that destroyed much of downtown Seattle resulted in an increased demand for milled lumber to rebuild. As trees and stumps were cleared, they created expanses that were converted to roads for wagons and later cars. Loggers on the surrounding plateaus used oxen and horses to pull logs down paths cut into the hills to Lake Sammamish, where they were then floated to one of several mills that operated on the shores of the lake. As the logging operations continued to move inland and away from the lake, it became more practical to move logs by rail car.

Boating on Lake Sammamish was necessary to transport logs to mills and, later, was a favorite pastime. Water skiing became popular on the lake in the 1950s. For example, the Lake Sammamish Water Ski Club was founded in 1956 and many of its members went on to compete and win in national championships. The most famous races on the lake, however, started in 1933 with the Sammamish Slough Races, where both motor boats and skiers traveled down the Sammamish River to the lake and back up to Kenmore, Washington.

Resort life boomed in the 1920s on Lake Sammamish. The lake road was paved by 1927 and extended all the way south to Issaquah. Resorts included Shamrock Cottage,

Gateway Grove, Idylwood, Pete's Place, and Vasa Park. These venues offered beach front, picnic tables, docks, playgrounds, and some, like Vasa Park and Idylwood, had dance halls. By the 1930s, nine resorts crowded the lake, five on the northwest shore alone. Resorts like Shamrock Cottage at the present day Northeast 38th Street, did a great business, especially during Prohibition. Many city departments saw the allure of the resorts. Norm's, Juanita Beach, Idylwood, Wildwood, and Meydenbauer were eventually bought by cities or King County and became public parks.

The cities on Lake Sammamish thrived at different times. Originally a small mining town, Issaquah was incorporated in 1892. As the mining deposits depleted in the late 1890s, lumber companies began exporting timber from Issaquah and other towns to Seattle and larger, rapidly growing communities throughout western Washington. Later, companies like Boeing and Microsoft contributed to the success of Issaquah as a residential city. Most recently, in 1996, Costco moved its global headquarters to Issaquah from Kirkland.

Bellevue, situated between Lake Washington and Lake Sammamish, was founded in 1869 by William Meydenbauer and officially incorporated in 1953. Prior to the opening of the Interstate 90 floating bridge across Lake Washington in 1940, Bellevue was mostly rural. Following the 1963 opening of the second floating bridge across Lake Washington, Bellevue became one of the largest cities in Washington.

Redmond was incorporated in 1912. After World War II, Redmond flourished as a suburb of Seattle. Redmond is home to several large, high-tech firms, including Microsoft, Nintendo, Honeywell, General Dynamics Airborne Electronics Systems, and Medtronics Emergency Response Systems.

The Sammamish area was referred to as "The Plateau" for years, and finally, after a decade of political arguing, one failed vote for incorporation and an unsuccessful attempt to incorporate with Issaquah, Sammamish was officially incorporated in 1999.

COMMUNITIES & HOMES
AROUND LAKE SAMMAMISH

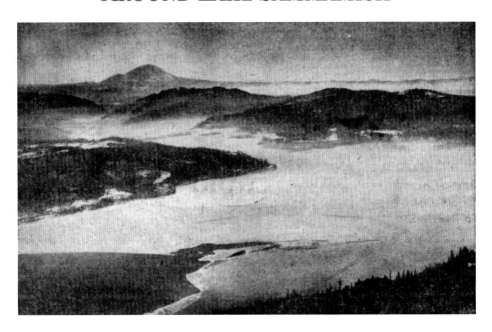

LAKE SAMMAMISH: Adelaide, Monohon, and Donnelly were several communities that lined Lake Sammamish in the 1800s and 1900s. (*From the collections of Redmond Historical Society*) Even in 1950, there were few housing developments along the lake, compared to today, where most of the shore line is developed. Lake Sammamish is surrounded by four cities, Issaquah, Bellevue, Redmond and Sammamish, and is lined mostly with residences, many of which have access to docks and beaches.

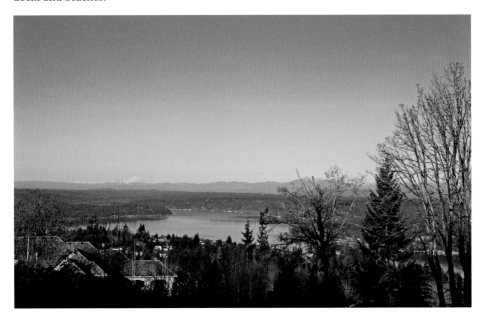

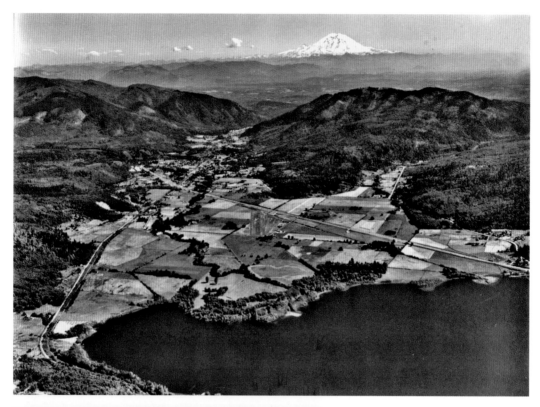

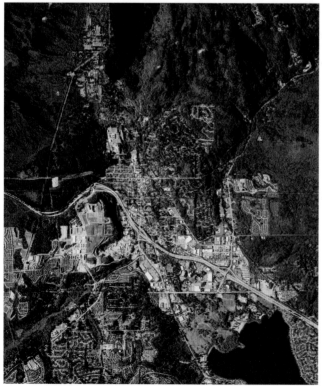

SOUTHERN LAKE SAMMAMISH: An aerial photo of the Squak Valley was taken from the east of Lake Sammamish, toward the south and Mount Rainier in 1947. *(Issaquah History Museums, 2005.010.005)* The cities of Bellevue and Issaquah sprang up, largely replacing farming communities in the surrounding cities of Issaquah (founded in 1885 and incorporated in 1892) and Bellevue (founded in 1869 and incorporated in 1953). Around the southern tip of the lake are mostly residential developments in the early twenty-first century. *(Photo from Image Trader www.landsat.com)*

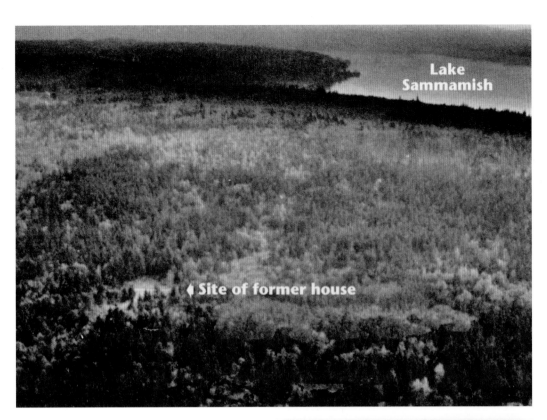

EASTERN LAKE SAMMAMISH: In 1965, there were very few homes in Sammamish between the lake and the plateau area. For most of its history, Sammamish has consisted of hilly terrain toward the lake and large plateaus. (*Courtesy Sammamish Heritage Society*) Sammamish was incorporated in 1999. In just forty years, it has developed into a mix of suburban, farm, and wetland areas. The satellite photo shows a stark increase in roads and housing developments. (*Photo from Image Trader www.landsat.com*)

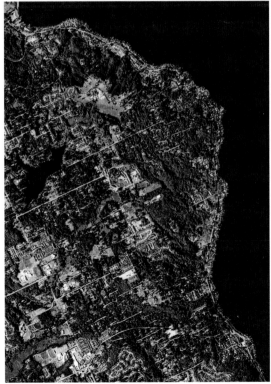

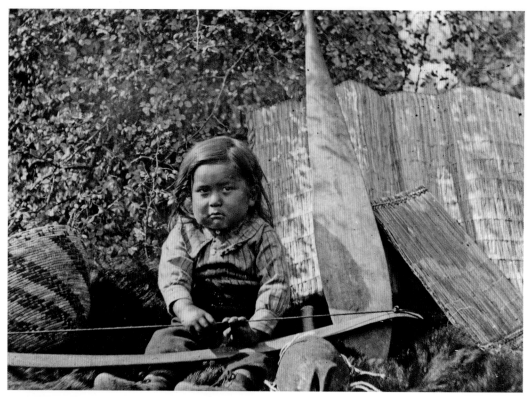

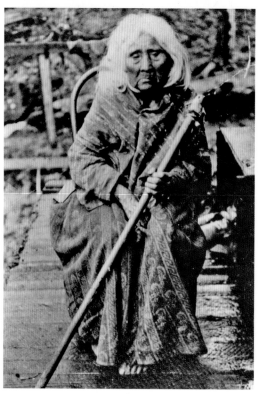

PEOPLE OF THE LAKE: The Snoqualmies and the Duwamish were two Native American tribes that resided on the eastside of Seattle. The landscape around Lake Sammamish was dotted with camps that included cedar-shake cabins and long houses that held up to forty people. In 1890, a Snoqualmie boy named Lolota Zickchuse, lived in a camp near Lake Sammamish. (*University of Washington Libraries, Special Collections, NA1416*) Mary Louie was a medicine woman of the Snoqualmie tribe. (*Issaquah History Museums, 86.018.308*)

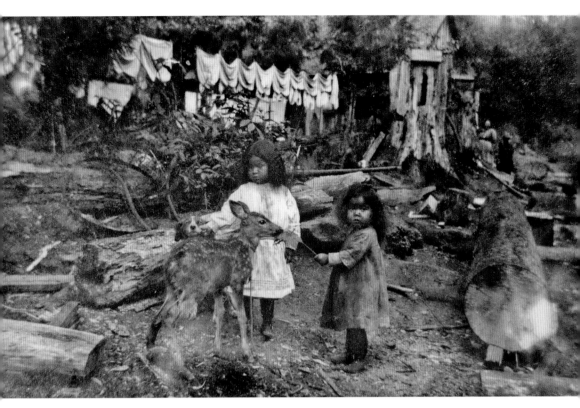

Two Native American girls, likely of the Davis family, play with a fawn at Inglewood settlement near Monohon on Lake Sammamish, *c.* 1911. They are members of the Lake Sammamish Snoqualmie, a band of the Snoqualmie tribe who moved to the shores of Lake Sammamish after the Point Elliot Treaty relocated them. (*Issaquah History Museums, 86.018.304*) Settlements have been replaced by housing developments along the lake shores.

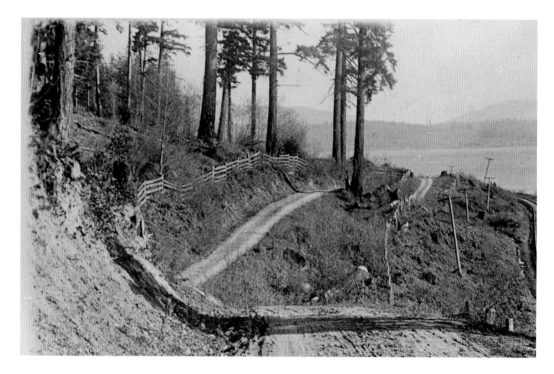

ADELAIDE: Adelaide, a company town operated by the Campbell Mill, was located on the northeastern part of Lake Sammamish. The mill opened in 1905 and, by 1909, Adelaide had a store, hotel, and railroad depot. This photograph shows East Lake Sammamish Road near Adelaide was being built below the railroad tracks along the lake. (*Courtesy of Eastside Heritage Center*) In 2014, the Adelaide area is bisected by the Redmond/Sammamish city lines at 187th Avenue NE, with the northern end in Redmond and the southern end in Sammamish.

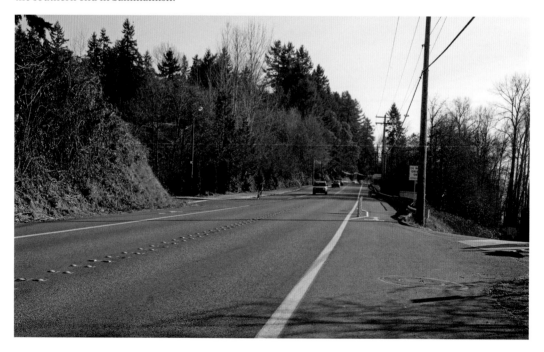

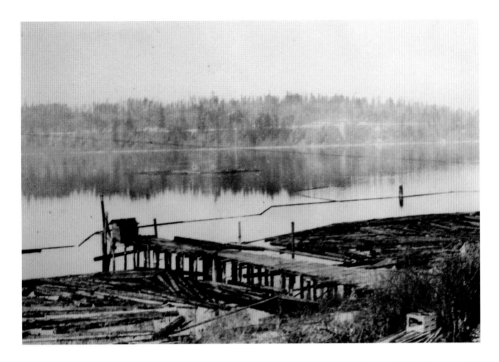

INGLEWOOD HILL: Inglewood was a community located on the eastern shore of Lake Sammamish between the 1890s and the 1930s. This logging dock was located at the foot of Inglewood Hill in 1932-34, which, eighty years later, is nestled among trees and hosts a variety of apartments and single family homes with more sheltered views of Lake Sammamish. (*Issaquah History Museums, 2000.019.001*) The area that makes up the Inglewood neighborhood consists of most of the original streets, but none have their original names. This view is taken from the intersection of Inglewood Road and East Lake Sammamish Parkway, looking toward where the above dock once was.

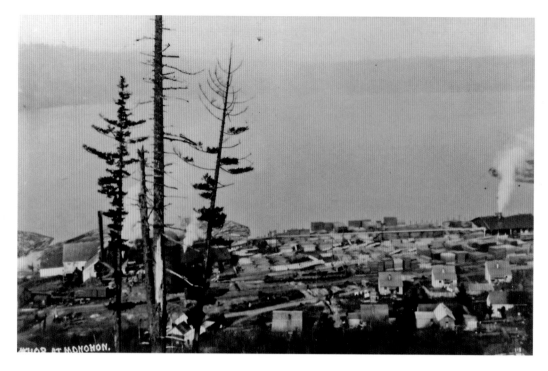

MONOHON: Monohon was named after Martin Monohon, who homesteaded 160 acres in 1877. By 1906, there were twenty homes, and a few years later, thirty more homes were built. Many homes were close along the lakeshore and homes up toward Pine Lake were also considered to be part of Monohon. (*Issaquah History Museums, 91.007.011*) By 1911, the town boasted a population of 300 people. The sweep of the shoreline shows Monohon shortly before a fire burned much of the community in 1925. (*Issaquah History Museums, 2009.028.002b*)

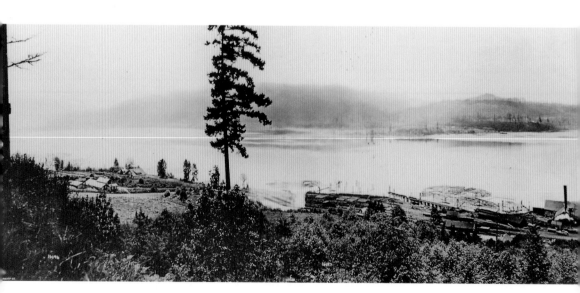

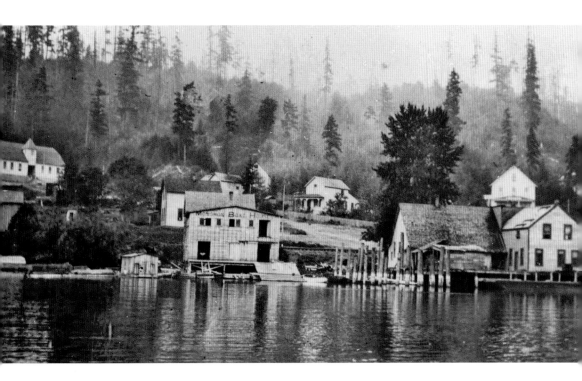

MONOHON: The Monohon Boat Works boathouse on the waterfront with the town in the background, as seen from Lake Sammamish, *c.* 1900s. Monohon was a company town with housing, a school, store, meeting hall, and hotel facilities. (*Courtesy of Eastside Heritage Center*) At one time, the company owned 120 acres along the lake and up the hill toward the plateau. Today, this area includes the Waverly Beach Community, near the intersection of East Lake Sammamish Parkway SE and SE 33rd Street.

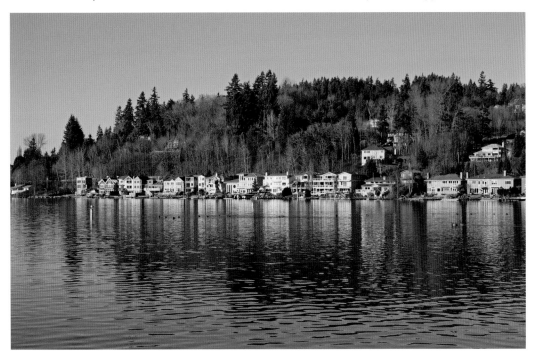

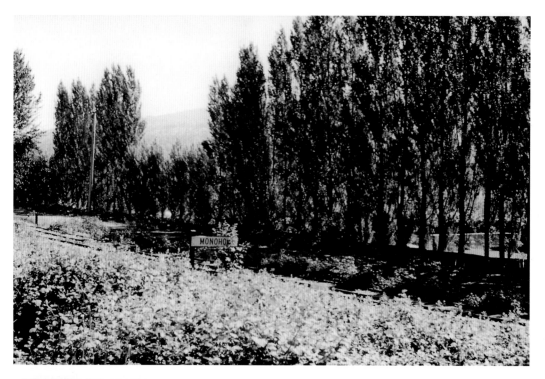

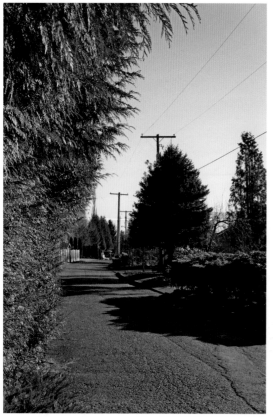

MONOHON: The old railroad sign for Monohon, here in the 1980s, was located along East Lake Sammamish Parkway, but has since been taken down and relocated to the Issaquah History Museums. (*Issaquah History Museums, 2004.041.105*) Today, the area once occupied by railroad is East Lake Sammamish Parkway and the East Lake Sammamish Trail, which passes by many homes, including Waverly Shores, a private neighborhood.

MONOHON: Development began in the 1970s and quickly spread throughout the shores of Lake Sammamish, as well as on the Sammamish plateau. The Lakeside Plaza Strip Mall, located at the base of the Monohon area, off of East Lake Sammamish Parkway. (*Issaquah History Museums, 2002.041.082*) From just a few paved roads in the 1960s to 167 miles of paved roads today, Sammamish has become more than just the rural town and plateau it was for many years.

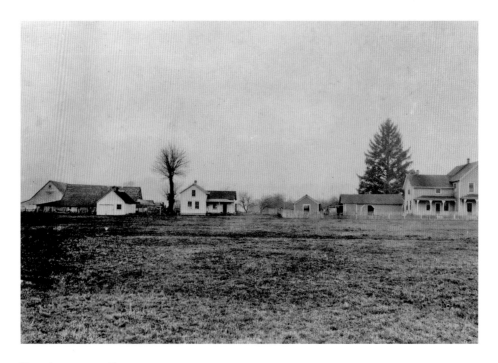

THE ANDERSON FARM: Before Lake Sammamish State Park existed, land on the banks of Lake Sammamish belonged to local farming families. The Anderson Farm belonged to John Anderson, a Norwegian immigrant, and his wife Addie. The Anderson Farm, *c.* 1920s, included the barn on the far left of the photograph, and the big house, with ten rooms, built in 1890. In 1934, Addie's three daughters inherited the farm. A tenant farmer named Ole Englebritsen occupied the land after 1934. (*Issaquah History Museums, 2003.023.001*)

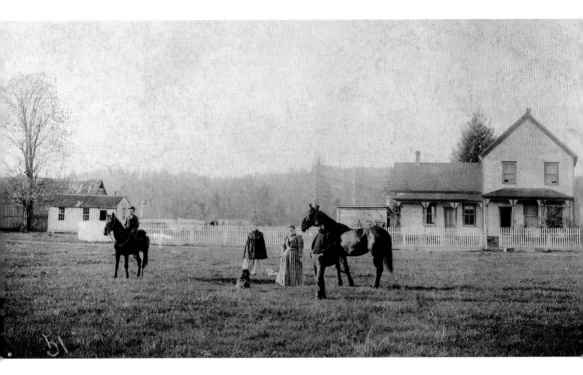

THE SMART FARM: The Smart Farm was located between Lake Sammamish and the Pickering Farm. On horseback, in 1885, is Lawrence Smart with his wife, Floss Durgan, wearing a cape. (*Issaquah History Museums, 2001.033.003*) In 1951, the State of Washington Parks Commission purchased the land of both the Smart and Anderson farms. Part of the Parks and Recreation Department for the state park resides on this land.

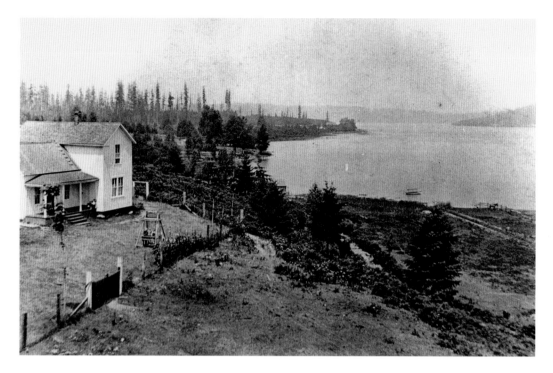

THE BARLOW FARM: John Barlow, son of a Finnish coal miner, bought a homestead at the base of Cougar Mountain in Issaquah in 1906. Barlow's dairy farm and barn were located at South Cove on Lake Sammamish until the 1960s. Barlow had the first gas powered boat on Lake Sammamish. (*Issaquah History Museums, 95.016.008*) The Barlow farm included the western parts of the Lake Sammamish State Park and waterfront on Lake Sammamish.

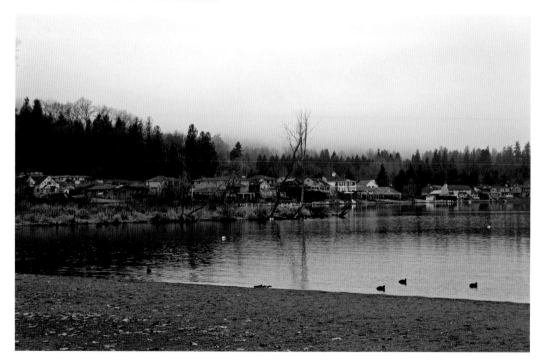

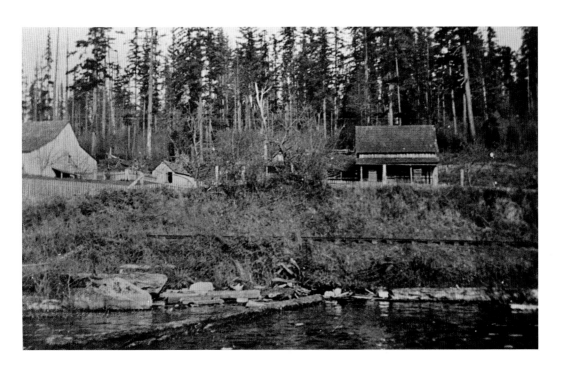

THE NORMAN HOME: William Davenport Norman's home was built on Lake Sammamish in 1890. His son, Lewis Davenport Norman, sold the seven-acre property to William Smith Quackenbush. The house was gone, but a barn and one room cabin remained. A Native American named Johnny Louie lived there when Quackenbush bought it. (*Courtesy of Eastside Heritage Center*) Today there are homes on the seven acres, one of which is 4604 East Lake Sammamish Parkway NE, north of Sammamish Landing, pictured here.

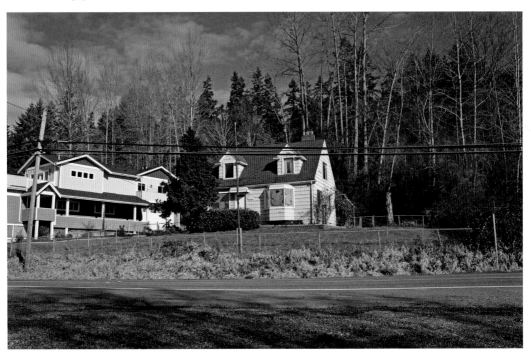

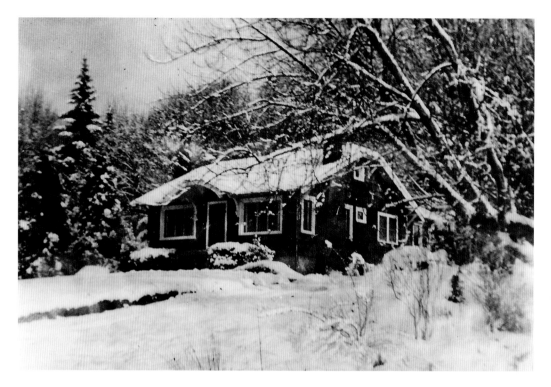

THE ZENGEL HOME: The Zengel home, located at 3228 NE East Lake Sammamish Parkway, had more than a dusting of snow on the ground in *c.* 1960s. (*Issaquah History Museums, 2005.001.016*) The house no longer exists as is, nor is there a house with the same address. A group of houses exists at the site, located next to the Soaring Eagle housing development along the parkway in 2014.

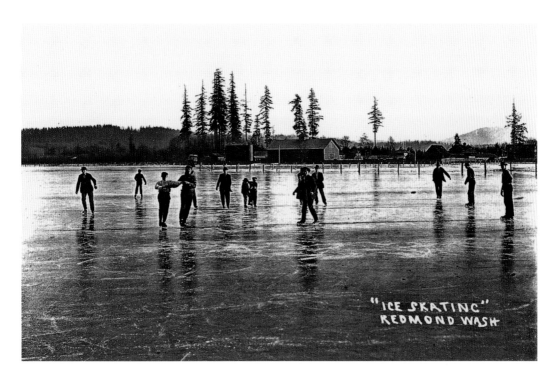

MARYMOOR FARM: Ice skaters enjoyed Lake Sammamish in *c.* 1910, with Marymoor Farm in the background. Many of the gentlemen are skating in suits and hats. (*From the collections of Redmond Historical Society*) Marymoor is located at the north end of Lake Sammamish and today is King County's most popular park, with more than 3 million visitors a year exploring 640 acres of land. Visitors can bird watch, rock climb, picnic, walk trails, and fly radio-controlled airplanes.

AROUND LAKE SAMMAMISH

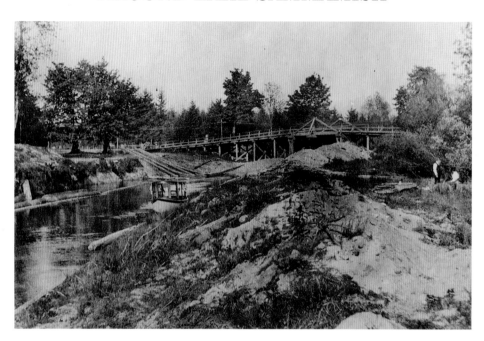

THE SAMMAMISH RIVER: The Sammamish River was a main artery of the valley in the nineteenth century with canoes, steamboats, and barges carrying people and supplies upstream and products like hay, logs, and butter downstream. In 1913, small boats transported people under the Redmond Bridge to have a picnic lunch along the banks. (*University of Washington Libraries, Special Collections, KHL018*) To reduce flooding, the river was dredged in 1964, creating the slough. The slough now connects the cities of Kenmore, Bothell, Woodinville and Redmond geographically together.

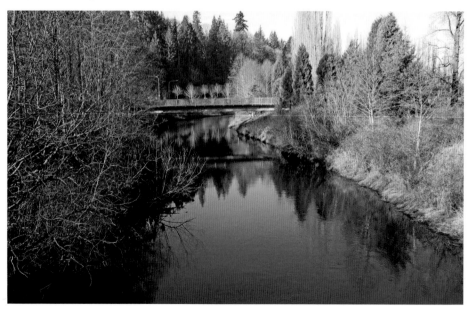

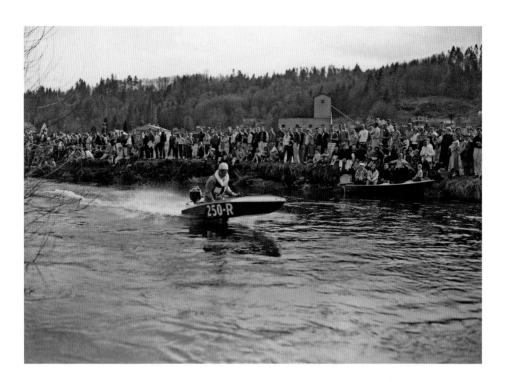

SAMMAMISH SLOUGH RACES: The Sammamish Slough Races started in 1928 and grew to host 50,000 spectators. Hydroplanes would race above eighty mph. This River/Slough played host to the American Powerboat Association and Seattle Outboard Association's first hydroplane race of the season from 1933 until 1976. The driver of the boat picture is Jim "Hotdog" Henry, racing his motorboat in 1952. *(Post-Intelligencer Collection, Museum of History & Industry, PI26528)* While the races no longer occur, many still use the slough as a place to fish and enjoy nature.

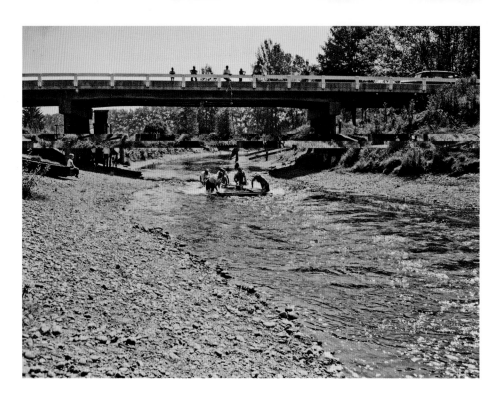

SAMMAMISH SLOUGH RACES: The race began from a dead stop near Kenmore's Air Harbor, wound upstream through thirteen miles of dangerous sand bars, log booms and bridges to Marymoor Park. After the "sweep boat" deemed the river clear of debris, not only hydroplanes, but water-skiers, canoes, and rafts, as shown in 1956, raced downstream, back to Kenmore. (*Courtesy of Eastside Heritage Center*) Today, the slough is a quieter scene.

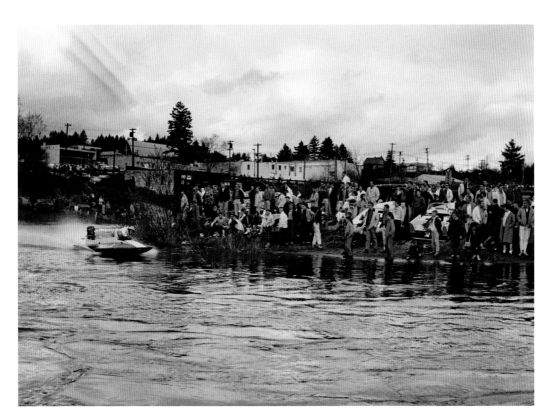

SAMMAMISH SLOUGH RACES: The races were still being held in 1961. To reduce flooding, the once a meandering river was straightened and dredged by the Army Corps of Engineers. (*Robert H. Miller Collection, Museum of History & Industry, 2002.46.7*) After further channel straightening in the 1960s, the races lost their excitement. The races ended in 1976 after an accident injured a spectator. The river winds along the Sammamish River Regional Trail, a 9.4 mile trail that runs from Marymoor Park in Redmond to the Burke Gilman Trail in Bothell.

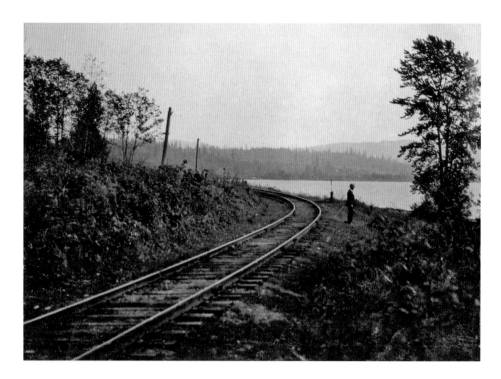

THE NORTHERN PACIFIC RAILROAD: In 1904, the Northern Pacific Railroad completed the 22-mile Lake Washington beltline, connecting Renton, Bellevue, Kirkland, and Woodinville. The section pictured is track from Issaquah to Redmond along the east side of Lake Sammamish, *c.* 1920. (*University of Washington Libraries, Special Collections, UW 35994*) In 2014, Lake Sammamish has trails that wind around it, sometimes through residential areas, that are used for biking, walking, and running.

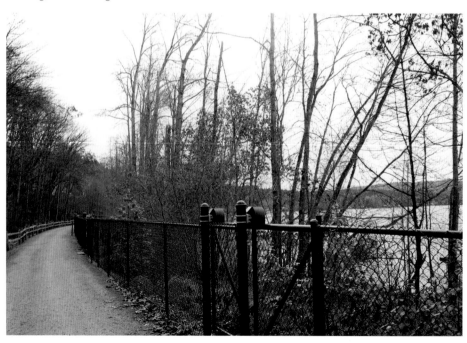

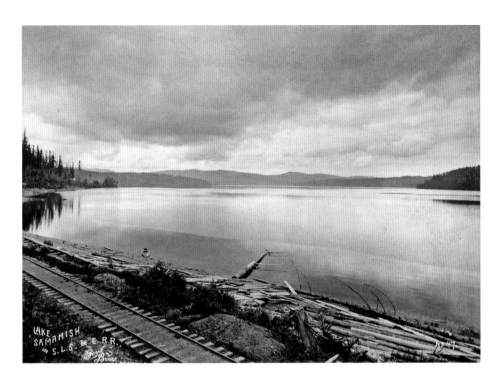

SEATTLE, LAKE SHORE & EASTERN RAILROAD: In 1887, the Seattle, Lake Shore & Eastern Railroad began construction. Tracks for the railroad were laid to Bothell in 1887, and by 1888, were brought down to the west side of the valley on the eastern edge of Lake Sammamish to Issaquah. Tracks of the Seattle Lake Shore and Eastern Railroad, Lake Sammamish, Washington, c. 1891. (*University of Washington Libraries, Special Collections, BAB14*) This area is mostly housing and private boat docks running along the East Lake Sammamish Trail in the early twenty-first century.

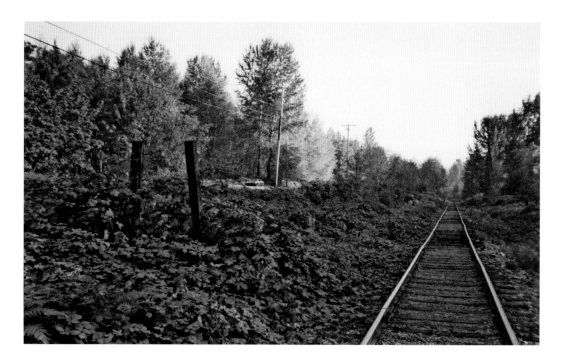

MONOHON RAILROAD TRACKS: Railroads operated along the East Lake Sammamish corridor from 1885 to 1996. With the laying of the rail in Monohon, goods could travel further east. Loggers, farmers, and coal miners benefited from the ability to ship good and materials east to the Snoqualmie area. (*Courtesy of Eastside Heritage Center*) In 1996, the Burlington Northern Santa Fe Railway suspended operations here. In 1997, King County and the Land Conservancy requested that a trail be created for bikers, walkers and runners.

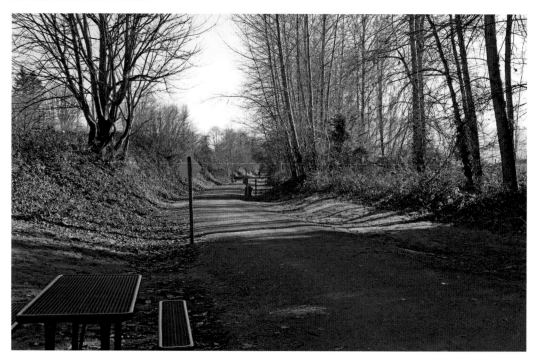

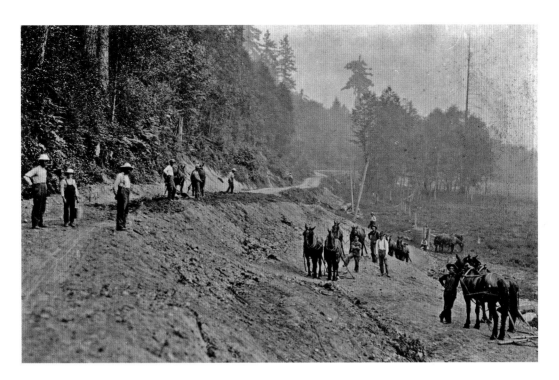

WEST LAKE SAMMAMISH PARKWAY: Road crews built West Lake Sammamish Parkway in 1910. The lake is to the right in this image. The road was built from Redmond south along the lake to Issaquah. (*Courtesy of Eastside Heritage Center*) A century later, West Lake Sammamish Parkway is heavily traveled by commuters to Redmond from Interstate 90 as well as the communities of Issaquah and Bellevue.

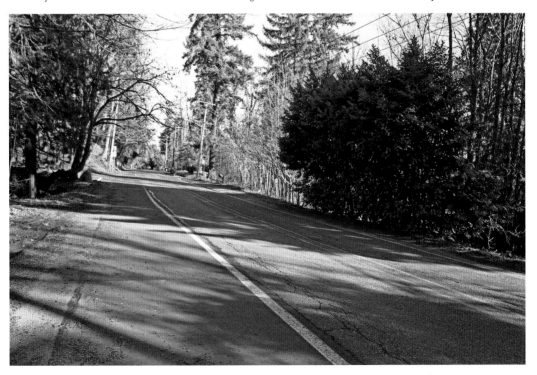

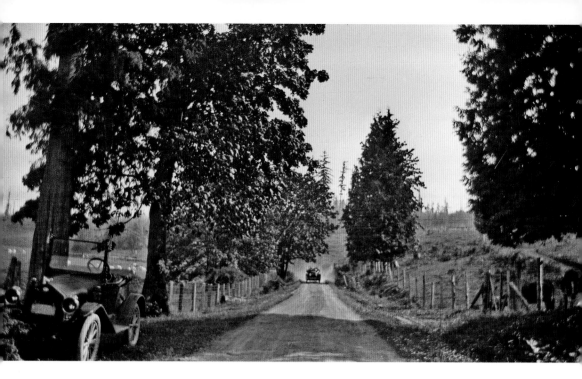

WEST LAKE SAMMAMISH PARKWAY: West Lake Sammamish Road ran from Redmond to Issaquah in 1920. Lake Sammamish is to the left of the picture. The road weaved through Bellevue, which was mostly rural at the time the road was constructed. (*Courtesy of Eastside Heritage Center*) West Lake Sammamish Parkway runs through Redmond, Bellevue and Issaquah, with several public parks like Marymoor, Idylwood, and Timberlake directly off of the road.

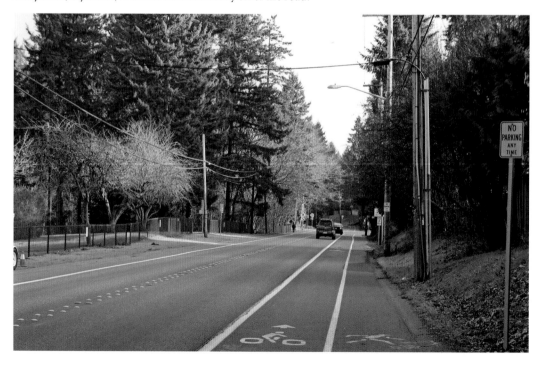

REDMOND DERBY
DAYS: Derby Days began
in 1939 as a 25-mile
loop around the lake,
starting from Redmond,
going down West Lake
Sammamish Road, back
east along the Sunset
Highway, and then back
to Redmond via East Lake
Sammamish Road. (*From
the collections of Redmond
Historical Society)* The race
prospered through the
1950s, but in the summer
of 1962 Interstate 90 was
finished through Issaquah,
eliminating the Sunset
Highway leg of the race.
The racecourse today
consists of several square
blocks in downtown
Redmond and hosts
contenders in the criterion
races, or bike races held on
a short course.

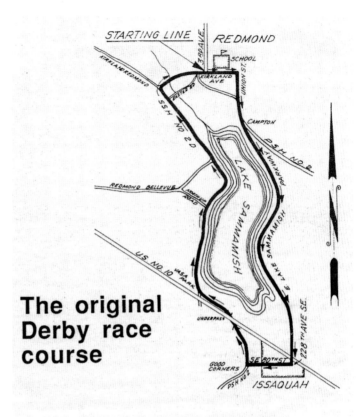

**The original
Derby race
course**

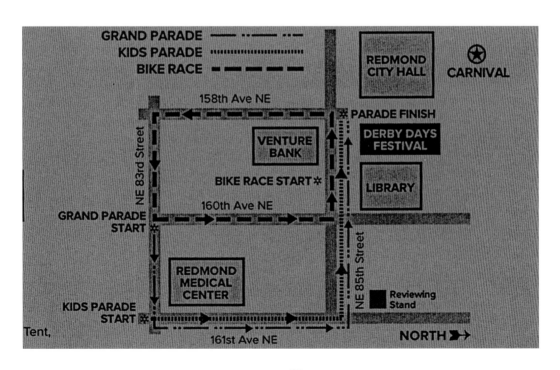

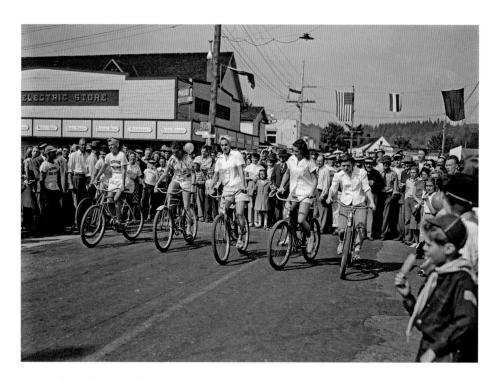

DERBY DAYS BICYCLE RACE: The bicycle race, run under the direction of the National Amateur Racing Authority, began in the early afternoon. There were classes for men as well as junior and senior boys and girls. Girls race on bikes at the derby in 1947. (*Post-Intelligencer Collection, Museum of History & Industry, 1986.5.6656.2*) Since 1980, the Derby Days changed to become a sanctioned criterion race through city streets rather than around the lake. Riders travel down 160th Avenue in downtown Redmond.

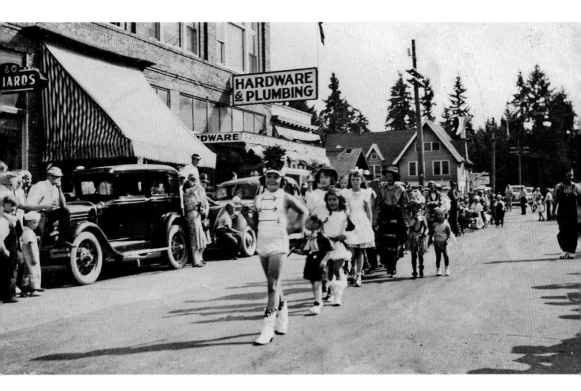

Derby Days Parade: Accompanying the bicycle race was a parade. The children's portion of the Derby Parade marched north on Leary Street in 1946. *(From the collections of Redmond Historical Society)* In 2014, the parade includes scout troops, politicians, and other groups like the Redwing Vaulters. Winners are chosen in categories including: Best Overall Float or Entry, Most Community Spirit, Best Drill Team, Most Original, Best Costume, and Mayor's Choice.

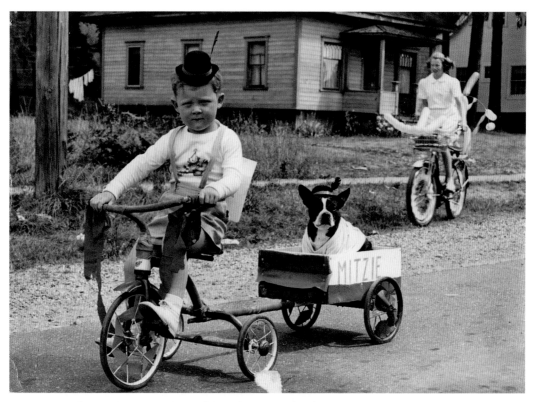

DERBY DAYS CHILDREN'S BICYCLE PARADE: Donnie Martin and his best friend, Derby Dog, owned by Liz Carlson, peddle his tricycle along NE 79th Street in 1949. (*From the collections of Redmond Historical Society*) Sixty years later, the criterion race is accompanied by the Derby Days children's bicycle parade, the longest running children's parade in the nation, and a carnival that lasts all weekend. Children and animals dress up and show their community spirit.

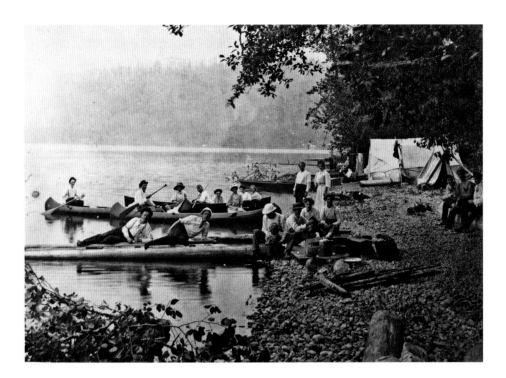

CAMPING AROUND THE LAKE: People traveled many miles to enjoy the shores of Lake Sammamish. In 1909, a Preston, Washington Baptist Church group camped at Lake Sammamish near Monohon on the east side of the lake. (*Courtesy of Eastside Heritage Center*) Overnight camping is prohibited in most places around Lake Sammamish, but there are several RV camps, including Vasa Park in Bellevue, and the Hans Jensen youth group camping area at Lake Sammamish State Park.

INDUSTRY ON LAKE SAMMAMISH

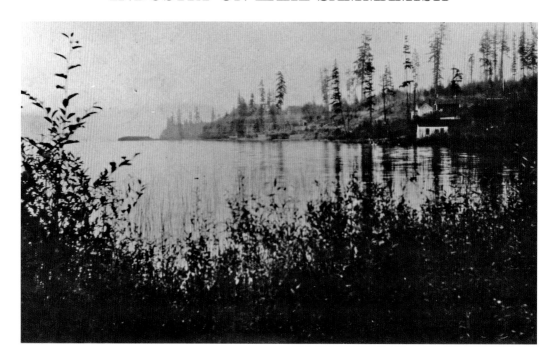

DONNELLY MILL: The Donnelly Mill, *c.* 1890–1900, was the first sawmill in Issaquah, established at the south end of Lake Sammamish in the 1870s. Donnelly was located at the mouth of Lewis Creek on Lake Sammamish. The mill equipment was later moved across the lake for the mill company established in Monohon called the Allen & Nelson Mill Company. *(Issaquah History Museums 74.043.018B)* Over a century later, Lewis Creek still runs to Lake Sammamish and is surrounded by homes in South Cove.

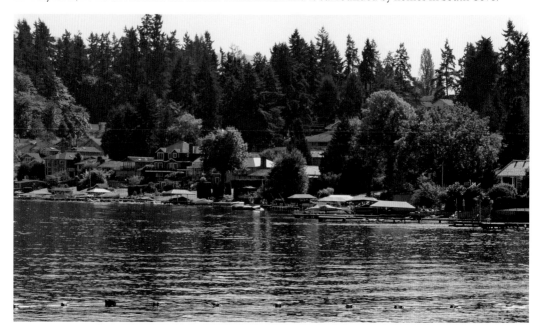

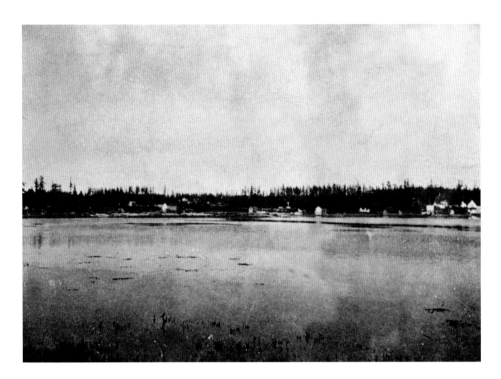

BRUNK'S LANDING: View of Lake Sammamish's southern shore, including Brunk's Landing, *c.* 1890. *(Issaquah History Museums, 86.018.293)* Brunk's Landing was a popular place to pick up the Squak boat, a vessel engaged in towing and freighting, traveling the entire length of the Sammamish slough into the lake and all the way south to Brunk's Landing. As the Squak departed Monohon, she would blow her whistle as many times as there were passengers on board. This would notify the Inn at the landing how many would want a hot meal upon arrival.

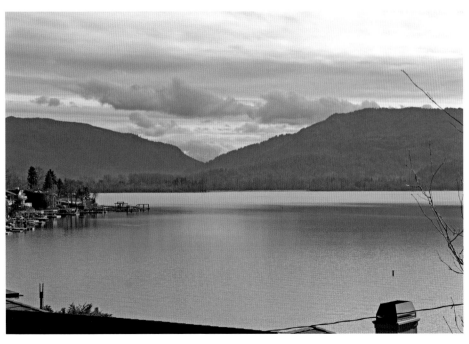

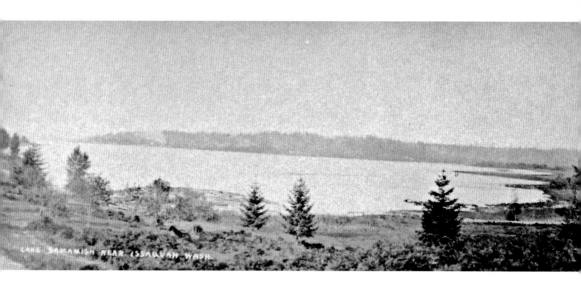

BRUNK'S LANDING: This photo was taken from the southwest end of the lake, looking past Martin Hoff's property near the Barlow farm area in Issaquah, *c.* 1890. The logs floating in the lake at the lower left were likely from the Donnelly Mill. (*Issaquah History Museums. 86.018.290*) The south end of Lake Sammamish is mainly Lake Sammamish State Park. The east side of the lake has been highly developed.

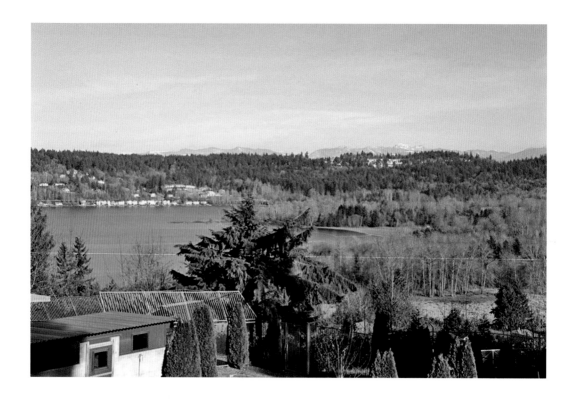

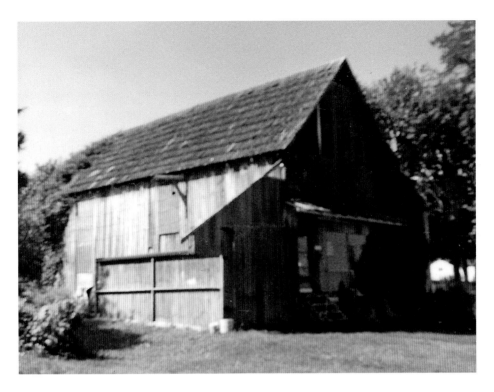

BRUNK'S LANDING: Martin Hoff's Barn at Brunk's Landing on Lake Sammamish, 1965. Issaquah's history includes a history of coal mining, logging and dairy farming. (*Issaquah History Museums, 72.021.014.238B*) Brunk's Landing became part of Lake Sammamish State Park. The photo below is to the west of the official entrance to the park in Issaquah toward Bellevue.

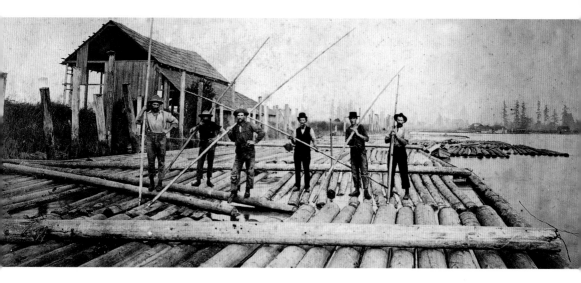

CAMPBELL MILL: These log walkers at Campbell's Mill, on the northeast end of Lake Sammamish, were experts at organizing floating logs into temporary rafts lined up off-shore, to await entry to the mill. Campbell was a large operation, beginning in 1905, with fifty men, two locomotives and sixteen miles of track. (*From the collections of Redmond Historical Society*) When the mill burned down in 1924, Adelaide's population dwindled. All that is left of the mill ninety years later are posts sticking up out of the water.

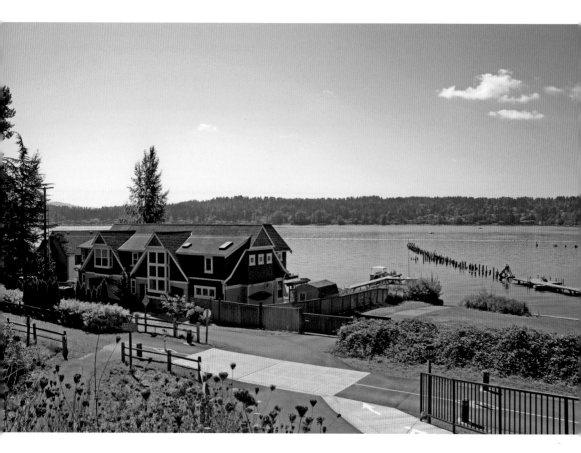

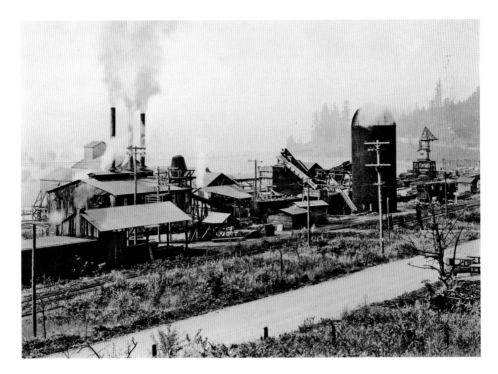

ALLEN AND NELSON MILL COMPANY: The Donnelly Mill moved its site to Monohon and a new company was established, the Allen and Nelson Mill Company, *c.* 1908–09. It would be Monohon's anchor for the next thirty-six years. Once the mill was up and running, logging operations along the east shore of Lake Sammamish quickly increased. One of the mill's first big jobs was to provide lumber for the city of Seattle to rebuild the downtown core that was destroyed in the Seattle fire of 1889. (*From the collections of Redmond Historical Society*)

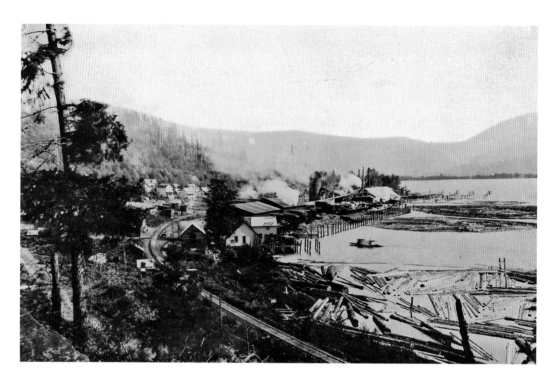

MONOHON MILLS: In 1889 the saws and equipment from Donnelly were moved to the eastern shore of Lake Sammamish. Lumbering and mill operations at Monohon contributed to the prosperity of Issaquah. This postcard shows Monohon's saw and planning mill in 1910. The water in front of the mill on Lake Sammamish is crowded with logs waiting to be milled. (*Issaquah History Museums, 91.007.011*) In 2014, the former Donnelly mill site offers a private dog run and housing along the lake.

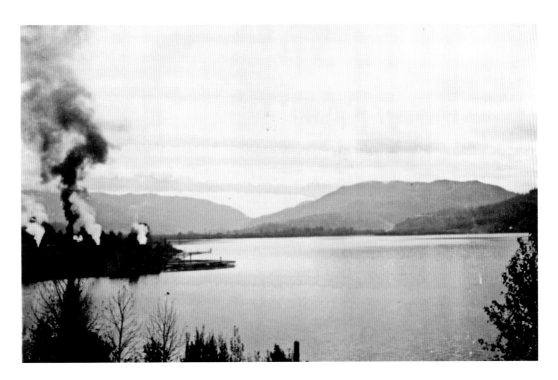

MONOHON MILLS: Scenic view of Monohon, mostly lake with smoke from mills on left, unknown date. (*Issaquah History Museums, 95.017.002*) Most of Monohon was destroyed by fire in 1925. Following renovation, it was destroyed by fire again in 1944. Several smaller mills were built after that, but following a 1980 fire, all operations at Monohon ceased. In the early twenty-first century, there are houses on the east side of the parkway.

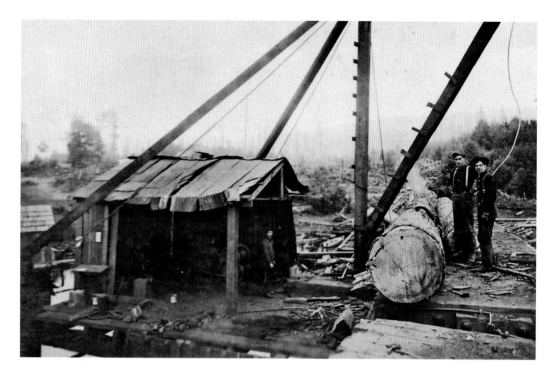

LEWIS CAMP: Logging at Lewis camp, where logs went over at Monohon, *c. 1900–1925.* Lewis Camp is where logs were put onto Lake Sammamish to be rafted to Monohon. Equipment shown here helped get the large logs into the water. (*Issaquah History Museums, 2012.019.019*) Logging in our area began to gradually wind down after the 1940s. The last mill actually on Lake Sammamish—the Issaquah Lumber Company, Monohon Mill—closed in 1980 and moved to Issaquah.

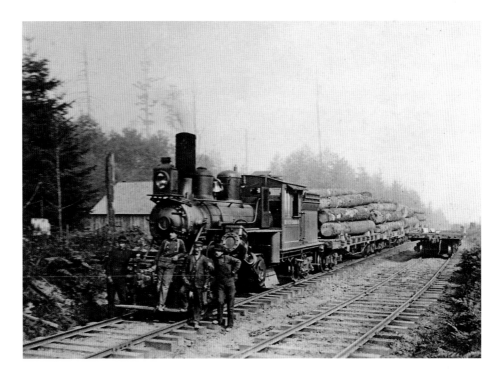

LEWIS CAMP: Steam locomotive from the Bennett Logging Company has three flatcars of logs at the Lewis Camp on the west side of Lake Sammamish. Logs were brought to the camp by oxen and would have been barged across to the lake to Monohon for milling. (*Issaquah History Museums 2012.019.01*) A steam donkey engine, commonly used logging equipment, is located in downtown Issaquah, standing as an example of the equipment used in the mills that built the towns around the lake.

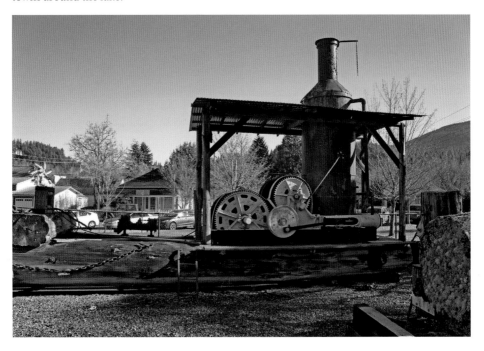

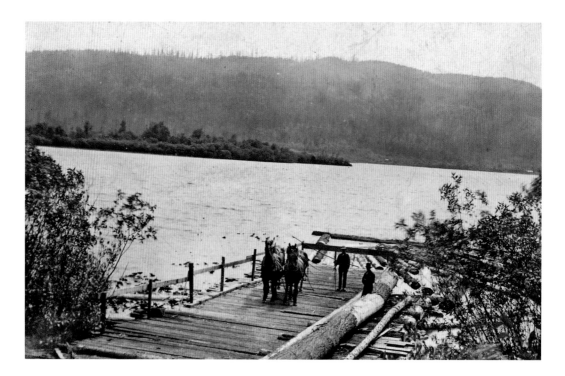

GIESE CAMP: Jack Bush tends to his horses at Giese, *c.* 1900–25. Logs were rafted from the Giese Camp on the west side of Lake Sammamish to the saw mills at Monohon on the east side of the lake. Horses were the best source of power for getting a smaller number of logs around the lake. (*Issaquah History Museums, 2012.019.031*) The area formerly known as Giese is part of Lake Sammamish State Park, near the Lake Sammamish boat launch in Issaquah.

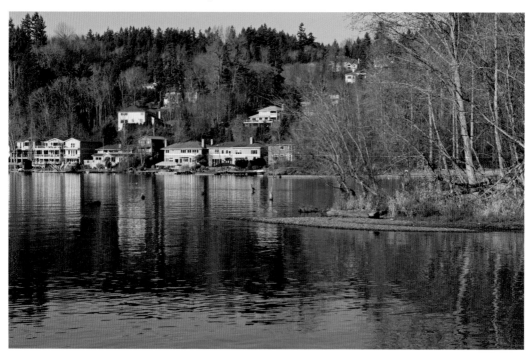

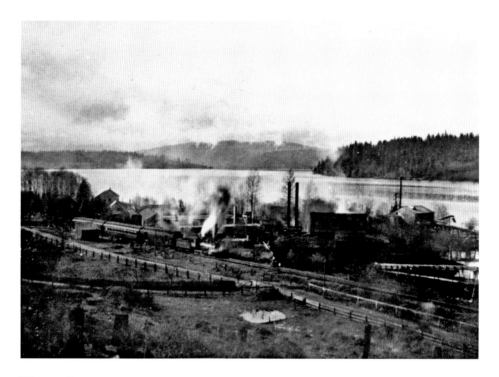

WEBBER POINT: Joseph Weber, originally from Ohio, moved his shingle business from Snohomish County to Lake Sammamish in 1901. Weber named it the Lake Sammamish Shingle Company, commonly known as Sammamish Shingle Company. The first mill was located on the tip of Weber Point, but between 1901 and 1907 Weber built a second mill. The mills produced up to 100,000 shingles (primarily cedar) daily. (*Courtesy of Eastside Heritage Center*) A hundred years later, Weber Point is a residential development along Lake Sammamish.

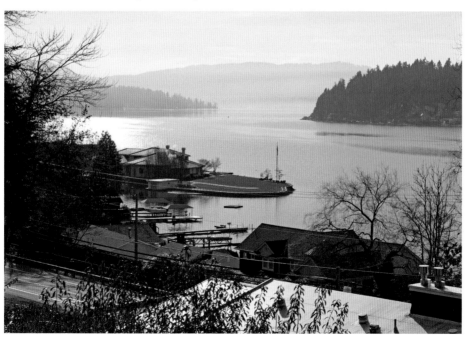

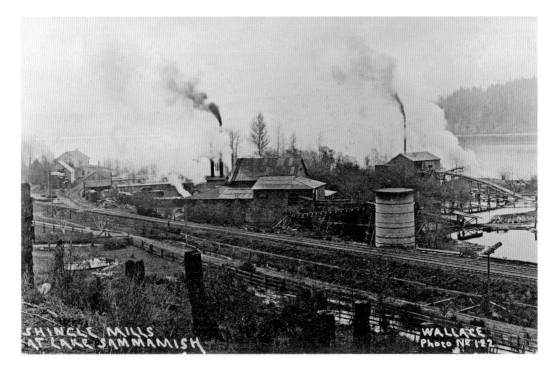

SAMMAMISH SHINGLE MILLS: Cedar logs were often floated in the inlet at Weber Point until they were ready to be cut. When they were, men guided the logs toward a chute which would automatically catch the logs and carry them into the mill to be cut into shingle bolts. Shingle mill, Lake Sammamish, Washington, *c.* 1910. (*University of Washington Libraries, Special Collections, UW 22102*) During the 1910s, cutting spruce trees came into favor because airplanes were increasingly built with spruce. Beginning in the 1940s, hemlock was logged on the plateau.

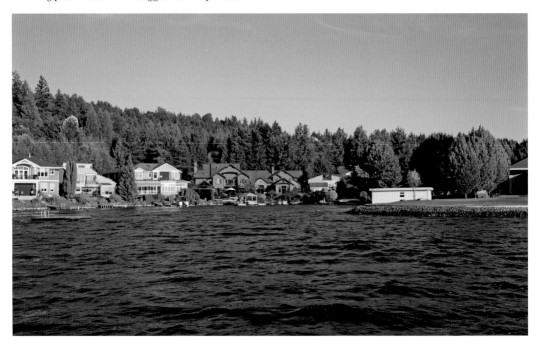

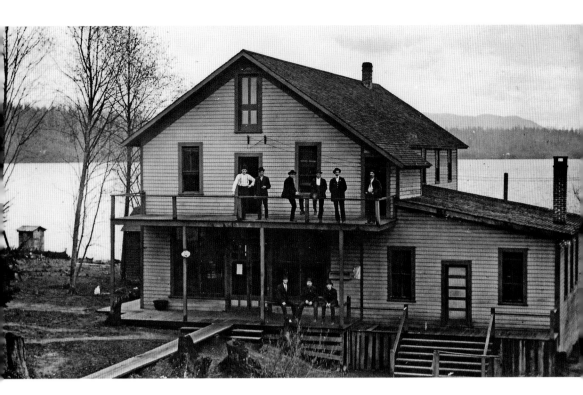

COOKHOUSE: By the early 1910s a company store, cookhouse, bunkhouse, dock and a few company homes had sprung up by the Sammamish Shingle Mill, pictured *c.* 1900. *(Issaquah History Museums, 2005.001.018)* By 1930 most of the trees near the eastern shores of the lake had been logged. The mill was significantly impacted by the Great Depression and the diminished supply of cedar trees around the mill. Weber was forced to close the Lake Sammamish Shingle Company in December 1930.

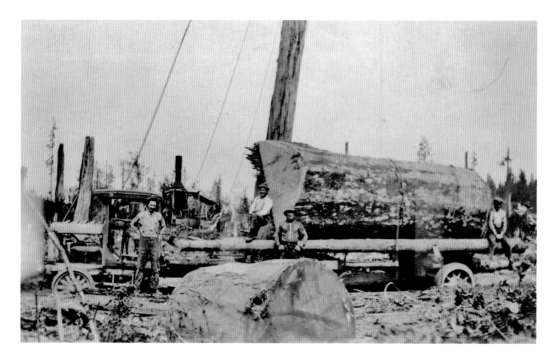

ISACKSON MILL: Huge old growth fir trees, some a thousand years old, covered most of the Sammamish plateau. Once a tree was down, loggers split the trees for easier transport, using oxen and horses, down to Lake Sammamish mills. Large three-wheeler Knox logging trucks were used to transport logs, *c.* 1914. Isackson Mill was built by Henry Isackson in 1931. (*Courtesy Sammamish Heritage Society*)

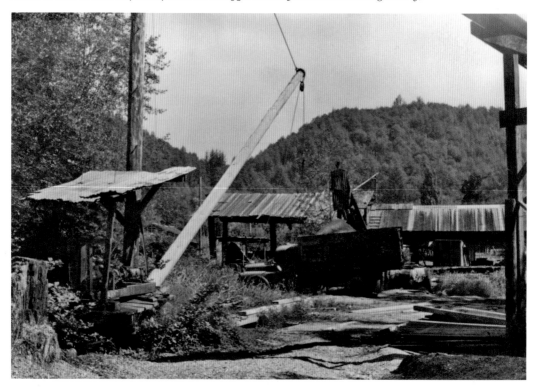

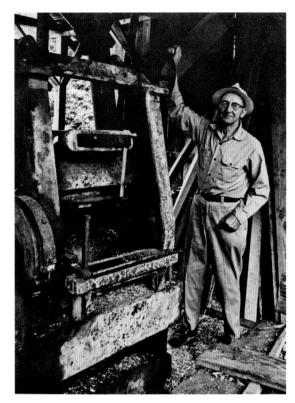

ISACKSON MILL: The mill was equipped with a 1936 #1 American Carriage, a Stetson-Ross planer purchased from the former Issaquah Lumber Company Mill at Monohon in 1949. Issaquah Lumber Company purchased it from a mill at High Point in 1940. In 1954, Isackson's was repowered using a diesel engine from a WWII landing craft. (*Courtesy Sammamish Heritage Society*) In 2014, Isackson Sawmill is located at 3019 244th Avenue NE and is operated by Duane Isackson, Henry's son. Customers order cedar saw dust for their stables and varying lengths of trunk trimming.

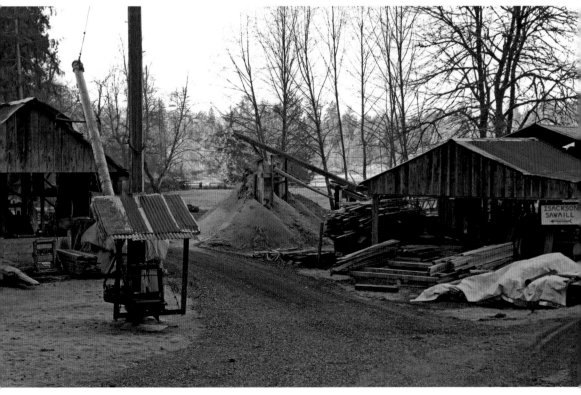

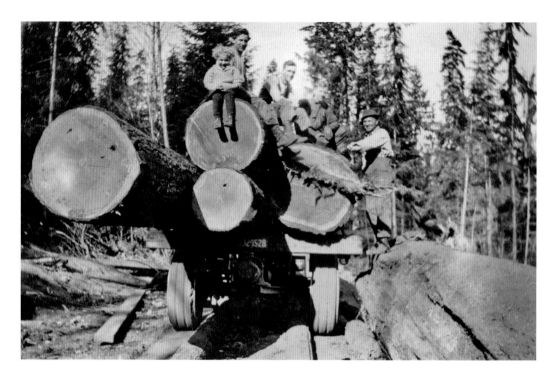

SAMMAMISH PLATEAU: In the early years of logging on the Sammamish plateau, the thousands year old trees closest to the lake were cut first. These cedar trees were logged from the plateau, *c.* 1930s. Loggers worked a 60-hour week during the early years of logging on the plateau, clearing land for farm sites. (*Courtesy Sammamish Heritage Society*) Much of the plateau is filled with second-growth trees, in which houses are nestled.

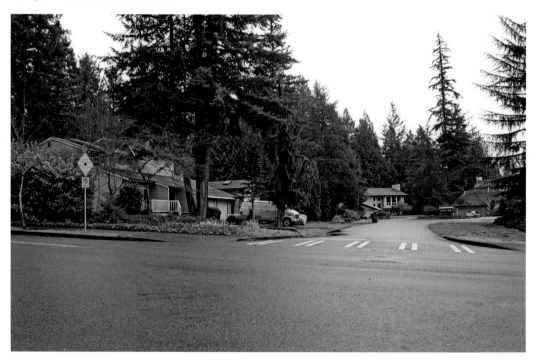

Lake Sammamish Resorts

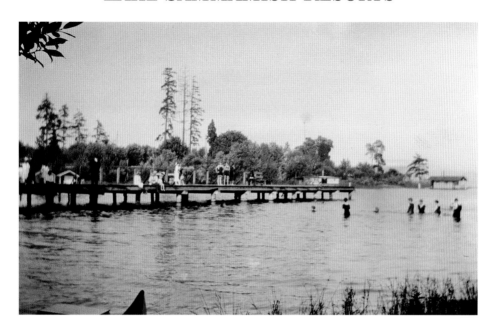

LAKE RESORTS: Orchard Park, Pete's Place, Shamrock, and Idylwood were resorts at the northwest end of Lake Sammamish in 1915. Orchard Park was the northernmost resort, owned by the Rohrbachers. Pete's Place and Shamrock were popular with fishermen from Seattle during Prohibition. Orchard Park was a family resort. All had boat rentals. (*Courtesy of Eastside Heritage Center*) The resorts disappeared in the 1960s and some became local parks. This area became a private fishing and boat dock on the northwest edge of Lake Sammamish by the early twenty-first century.

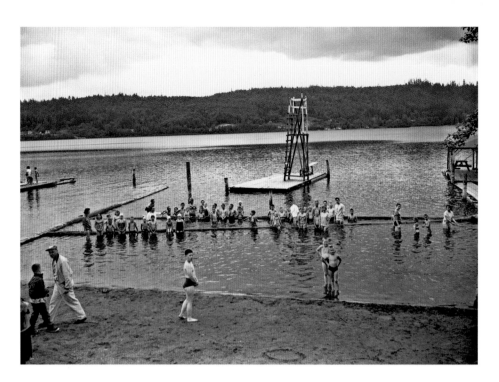

GATEWAY GROVE: Gateway Grove Resort was developed in 1927 by the Charles Enis family, who also built cottages as rental properties, a boathouse, dock and playground. The property changed hands in 1951 when it was sold to Chandler and Myrtle Pickering, who built a 40-foot slide and a high diving board. Gateway Grove Resort hosted events like this end of the school year party in 1956. (*Courtesy of Eastside Heritage Center*) King County purchased Gateway Grove and Idylwood in 1969 and combined it create Idylwood Beach Park.

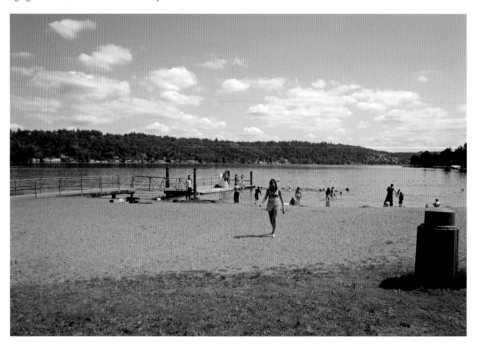

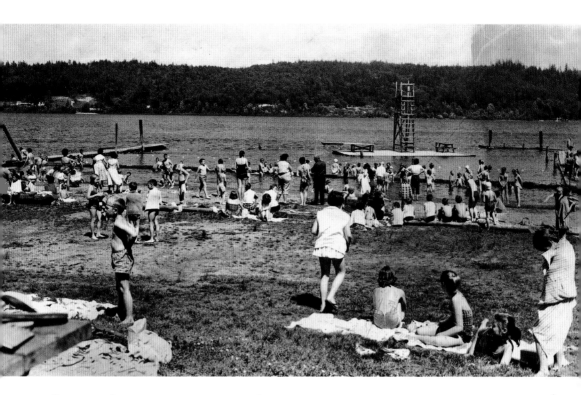

GATEWAY GROVE: Gateway Grove Resort beach area is packed with beach goers in 1959. (*From the collections of Redmond Historical Society*) The City of Redmond Park features a swimming beach, including bathhouse and restrooms, a small boat launch ramp, picnic tables, playground, volleyball area, shelters and barbeques.

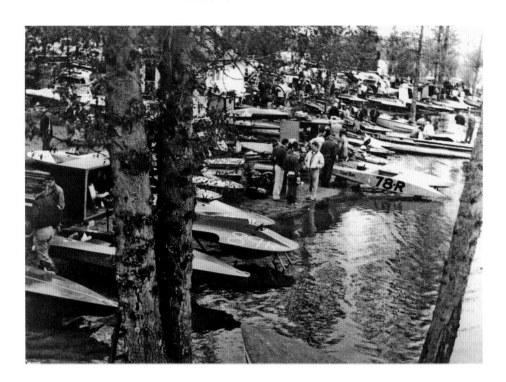

GATEWAY GROVE: During the 1950s, water skiing, sailing, and motor boat racing were popular activities for the guests at Gateway Grove. (*Courtesy of Eastside Heritage Society*) Immediately after Sammamish incorporated in 1999, the City of Sammamish enacted a boating ordinance regulating boating activities. The only watercraft permitted to launch via Idylwood Park, formerly Gateway Grove, are personal, non-motorized watercraft like kayaks, canoes and paddle boards. Many guests fish off of their watercraft.

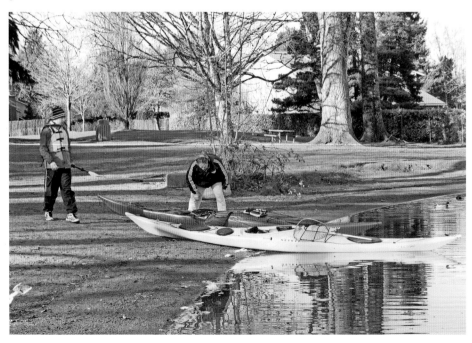

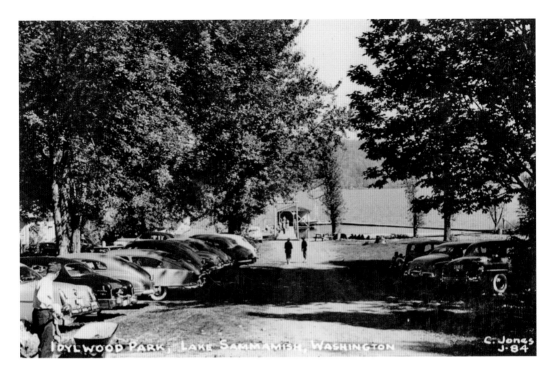

IDYLWOOD: Idylwood was originally built as a vacation cottage resort called Chandler's Gateway Grove. The Idylwood Park boat ramp was filled with cars, *c.* 1950. (*Courtesy of Eastside Heritage Center*) In the summer, lifeguards are provided for safety, and there is a snack shack. King County gave both Gateway Grove and Idylwood to the City of Redmond in 1994.

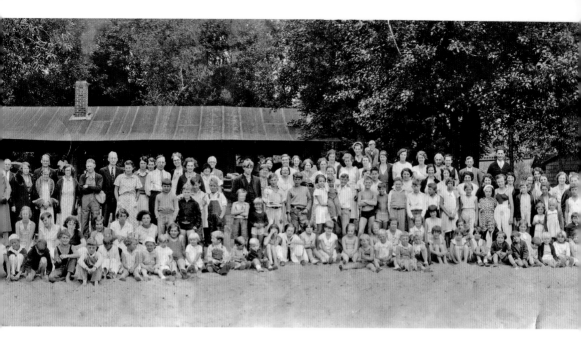

ALEXANDER'S BEACH RESORT: Near the southern end of Sammamish's city limits was Alexander's Beach Resort, originally purchased by Thomas Alexander. In 1902, Thomas and his wife, Caroline, built a large house on their 160-acre property which later become known as the Alexander House. In 1917, Caroline decided to open a picnic resort on the property closer to the lake, and created Alexander's Beach Report. Picnickers gather, *c. 1931–44.* (*Issaquah History Museums, 2007.009.001*) The Alexander Beach Resort area in 2014 has a group of homes that are part of the Alexander-on-the-Lake development, located near 206th AVE SE.

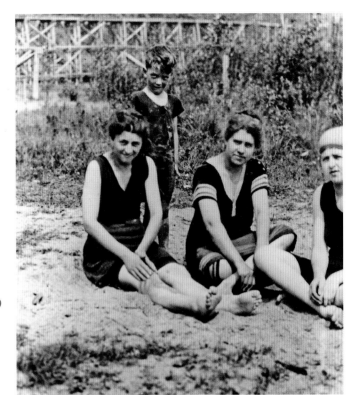

Mary Allyn, Mattie Ray Tibbetts, and Ferol Tibbets pose at Alexander's Beach Resort, *c.* 1915. (*Issaquah History Museums, 2003.008.008*) While thousands of people live along Lake Sammamish, many more thousands visit the lake, like these high school students on a sunny winter day.

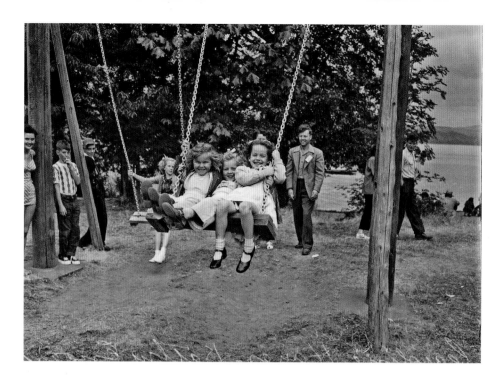

VASA PARK: Vasa Park was built in 1926 by a Swedish cultural group. Not far from it was a bible camp, built in 1919. Many Swedish families in the Seattle area belonged to the Vasa Order, a fraternal organization. Pictured here in 1949 at the Swedish Picnic are Caroline Hayes, Kathy Enger, and Christy Smith. (*Post-Intelligencer Collection, Museum of History & Industry Photograph Collection, P122501*) The Vasa Park and Resort of 2014 is much like it was in its heyday, offering camping, picnicking and swimming.

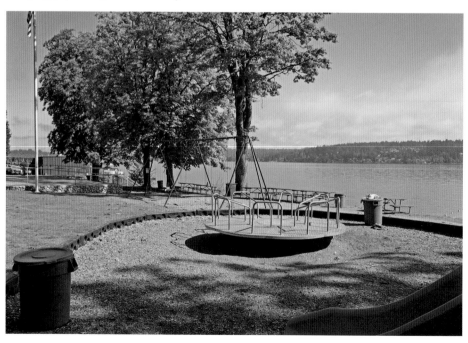

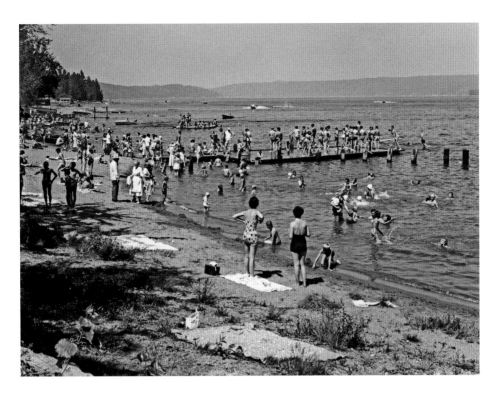

VASA PARK: Every June, Vasa Lodge 13 held a Swedish Midsummer Festival at Vasa Park on Lake Sammamish. In this 1958 photo, children and adults enjoy the sun and the water during the annual Swedish Midsummer Festival at Vasa Park. (*Post-Intelligencer Collection, Museum of History & Industry, PI22507*) Similar to the park fifty years ago, modern Vasa Park has a swimming area, complete with water slide and provides a lifeguard for safety.

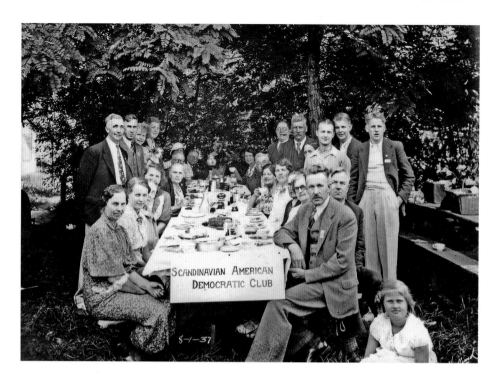

VASA PARK: During the nineteenth and early twentieth century, people of Scandinavian origin immigrated to America in search of land, security, freedom and social mobility. They worked in many sectors of the economy and developed social, political, religious, and cultural institutions that celebrated their heritage. Scandinavian-American Democratic Club members at Vasa Park, Lake Sammamish in August 1, 1937. (*University of Washington Libraries, Special Collections, UW 35995*) The public is able to use Vasa Park for a small fee.

ON THE WATER

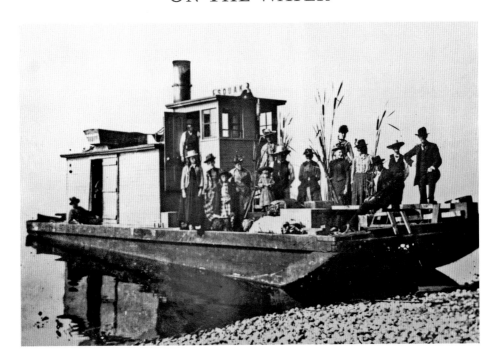

BOATS: The boats on Lake Sammamish, formerly known as Squak Lake, carried passengers as well as products. This Squak boat carried freight and people for five years, from 1884 until 1889, when a violent storm destroyed her in Kirkland. The boat did not keep to a schedule. When someone wished to ride, he or she had to wave a flag from the shore to get the captain's attention. (*Courtesy of Eastside Heritage Center*) Boats are moored at personal docks along Lake Sammamish.

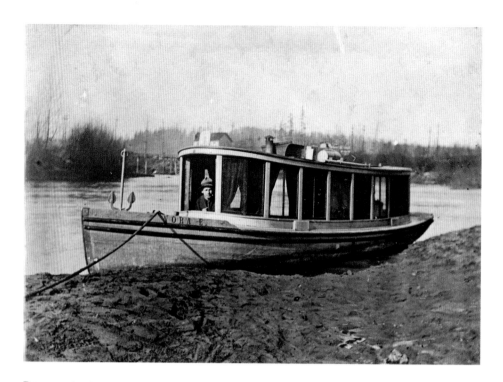

BOATS: This boat, likely docked on Sammamish Slough, is named Nora E. Goode, *c. 1908–15*. Boats transported passengers and products from Sammamish Slough to farms and mills on Lake Sammamish. (*Issaquah History Museums, 93.013.018*) Fiberglass trophy fishing boats are seen on Lake Sammamish, usually trolling for wild coastal cutthroat trout, smallmouth bass, perch, brown bullhead, kokanee, and steelhead trout. Some salmon species are closed to fishing, and others depend on abundance.

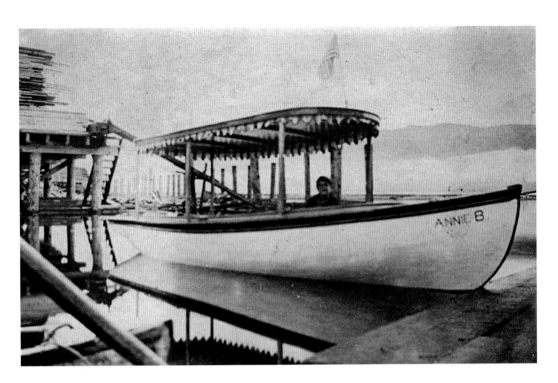

ANNIE B: Charles W. Bennett's wife, Annie, sits in the "Annie B" boat at Monohon, *c.* 1910–25. The boat sits next to a pile of lumber milled at Monohon. The Issaquah Press lists the boat launched by the Monohon Boat & Canoe Company in February of 1909. (*Issaquah History Museums, 2012.019.002*) Of the many boats present on the lake, speed boats, used to pull water skiers or for fishing, are prevalent.

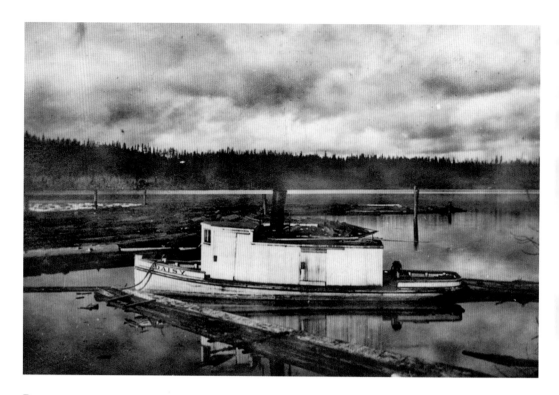

DAISY: A wooden tug boat "Daisy" on Lake Sammamish, 1925. Paddles, oars, and poles propelled people and freight between settlements until steamboats and tugboats began operating on the lakes and rivers. (*Courtesy of Eastside Heritage Center*) A tugboat delivers and steadies huge drilling equipment and an excavator at the Lake Sammamish boat launch in Issaquah.

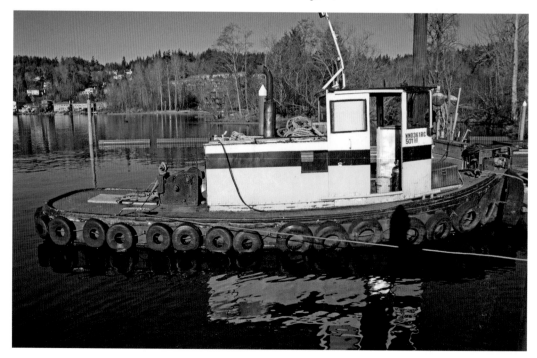

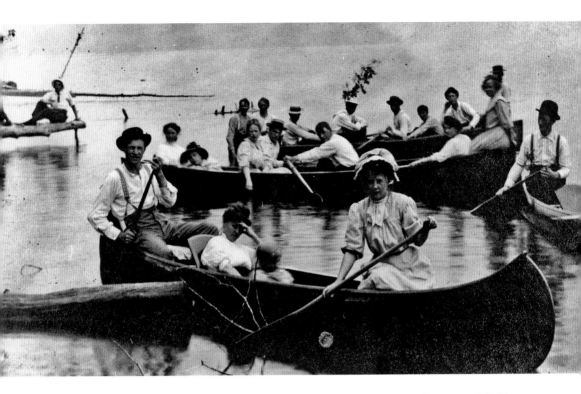

CANOES: Canoeing has always been a popular pastime on Lake Sammamish. Preston, Washington Baptist Church members canoe in Lake Sammamish in 1912. (*Courtesy of Eastside Heritage Center*) If people do not have access to the lake via house or property rights, there are various public boat launches around the lake in 2014. Kayak and canoe rentals are available from a number of local vendors, including Issaquah Paddle Sports and Kayak Academy.

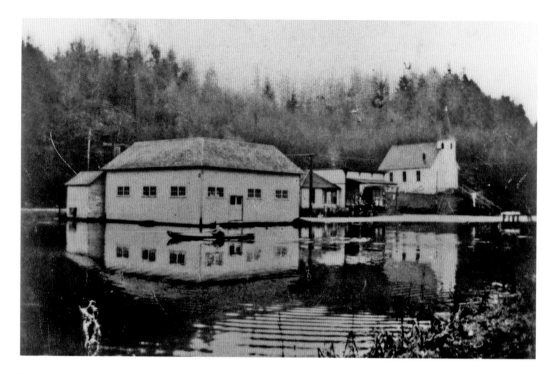

ROWING: Boathouse at Gateway Grove Resort, date unknown. (*Courtesy of Eastside Heritage Center*) The Sammamish Rowing Association built a new boathouse in 2011 around the bend in Lake Sammamish to the north. The ground floor houses three boat bays, with ample room for rowing shells of all sizes. The second floor boasts a multipurpose room for indoor training days, meetings, offices, storage, and social events.

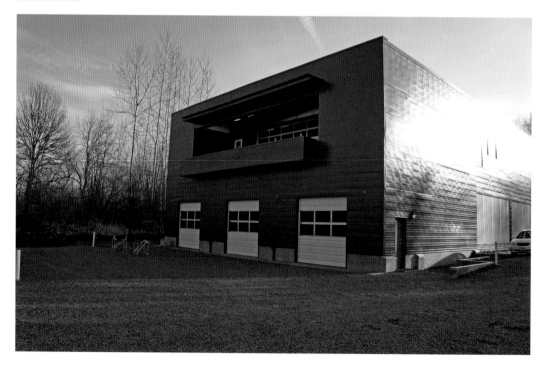

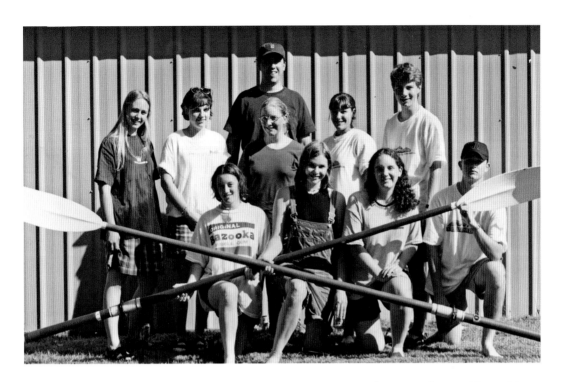

ROWING: The first Sammamish Rowing Association Juniors, 1996 (*L to R, B to F*): Jamie Meyers, Lisette Wolter, Coach Dave Mitchell, Maggie Dwyer, Nick Livingston, Alana Saffitz, Claire Biggs, Jordan Pickrell, and Matt Durant. *(Courtesy Sammamish Rowers Association)* Sammamish rowing club, started in 1995, partnered with the King County Parks to create a boathouse near Idylwood Park in Redmond. Today, there are numerous programs run out of the newly remodeled boathouse facility.

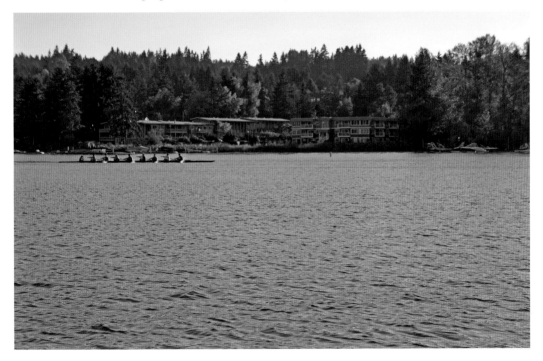

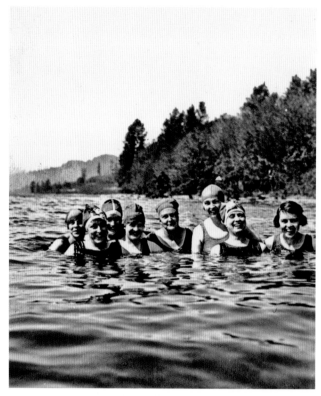

SWIMMING: Edith Usher Beers, second from the left, swims with friends in 1923. (*Issaquah History Museums, 2000.003.003*) A local woman braves the January chill to swim at Idylwood Park in Redmond. Beginning in 1996, selected swimming beaches on Lake Sammamish are monitored weekly from mid-May through Labor Day for bacterial pollution levels to determine if there are health risks to swimmers. If unacceptable risk is present, the Seattle/King County Public Health department will advise beach managers to post signs on a beach warning of the risk to swimmers.

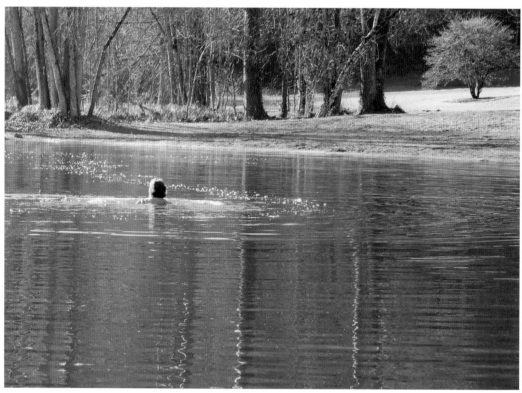

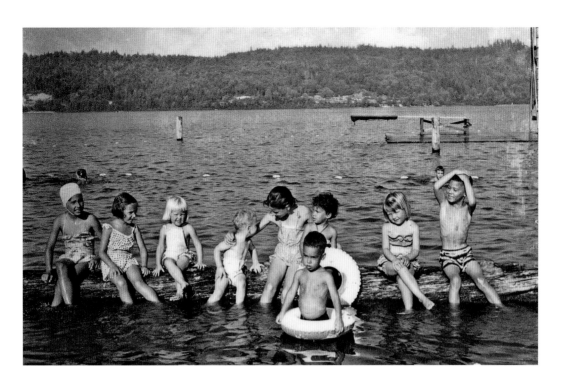

GATEWAY GROVE: Kids take a break from swimming at the old Gateway Grove Resort in *c.* 1950s. *(From the collections of Redmond Historical Society)* Rain or shine, and in any weather, children play at the shoreline of Lake Sammamish. Even in the winter, when it is too cold to swim the waters, children find activities, like playing in the sand.

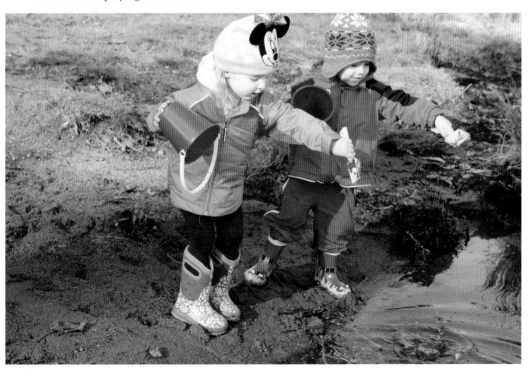

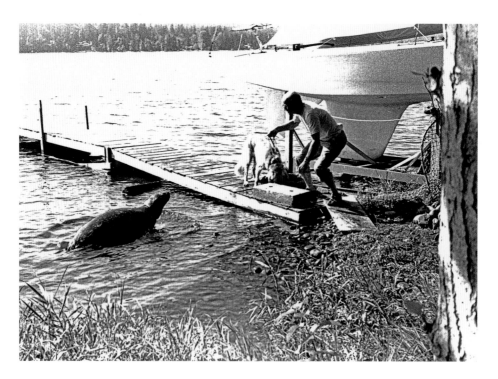

ANIMALS ON THE LAKE: For twenty-five years, a harbor seal named Butch was friend and neighbor to many folks living along Lake Sammamish. He was first seen in the lake in 1950, most likely abandoned by someone who tired of him as a pet. Occasionally, Butch would run afoul of someone who didn't like having a harbor seal in the neighborhood and Fisheries officers would be called in. (*Courtesy of Eastside Heritage Center*) Ducks are prolific on the lake in the 2010s.

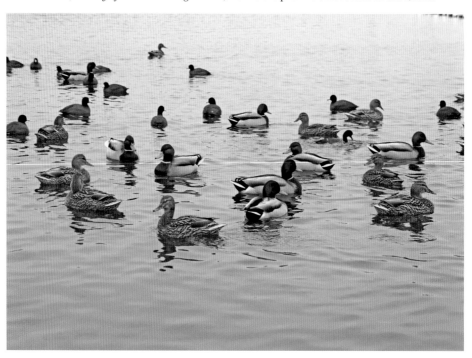

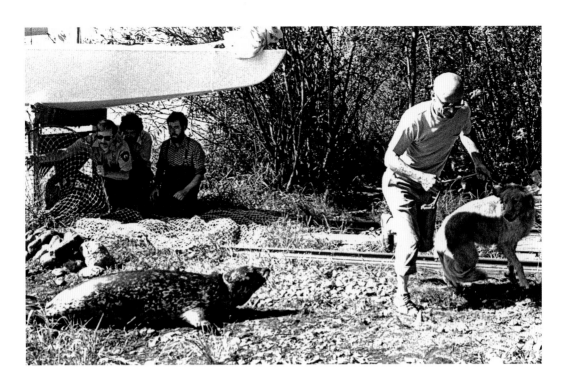

BUTCH: In December 1952, fisherman complained that the seal was eating all the fish. In his later years, the aging seal became aggressive. The Washington State Dept. of Game intervened and captured Butch with nets in 1975. At the time of his death, it was noted that Butch lived past his normal life span, likely due to his lack of natural enemies and an abundance of caring friends in the lake community. (*Courtesy of Eastside Heritage Center*) Seagulls feed on fish at Lake Sammamish State Park.

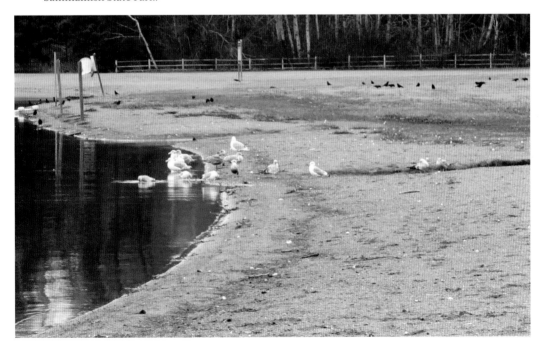

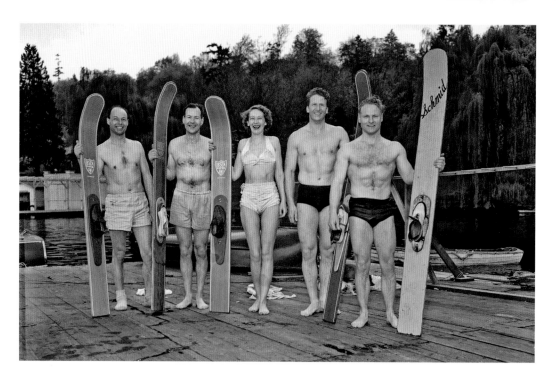

WATER SKIING: On April 28, 1948, Seattle area water skiers were all set to compete in the Sammamish Slough Race, running from Lake Washington, through the slough, to Lake Sammamish. Olympic Water Ski Club members Lyle Tenney, Tom Brown, Lorraine Stephens, Bob Schumacher and Bill Schmidt gathered on a Seattle dock. (*Post-Intelligencer Collection, Museum of History & Industry, PI26998*) Water skiing is still a popular sport on the lake in 2014.

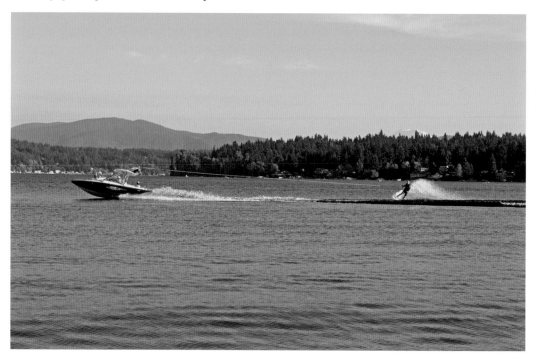

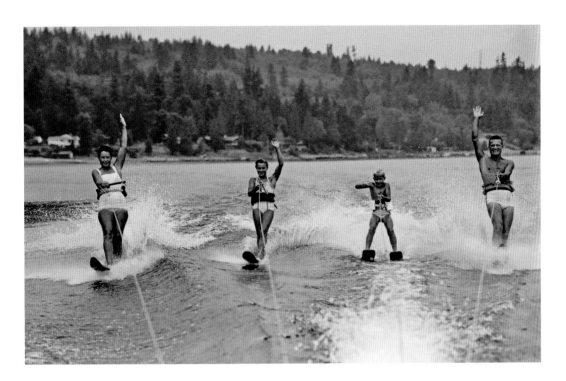

LAKE SAMMAMISH WATER SKI CLUB: The Gering family, Lloyd, Phyllis and their children, water skiing at Lake Sammamish in 1960. (*Post-Intelligencer Collection, Museum of History & Industry, 1986.5.26097.1*) Lake Sammamish Water Ski Club began in 1956 when they first installed a slalom course on the lake. They support many forms of water sports, including wakeboarding, kneeboarding, barefooting and wakeskating.

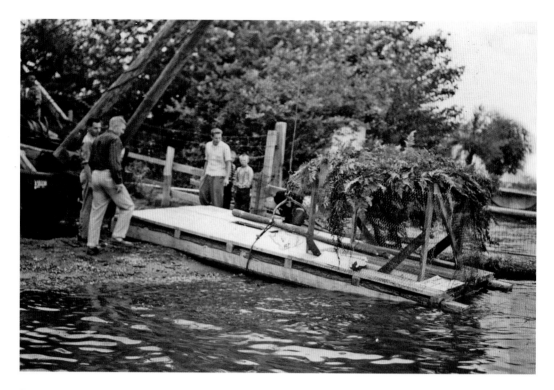

BOAT LAUNCHES: Launches were used for various craft on Lake Sammamish, *c.* 1959. (*From the collections of Redmond Historical Society*) Boat launches exist all around Lake Sammamish, specifically at Lake Sammamish State park boat launch, smaller launches within the park itself, the Sammamish Landing launch site, Vasa Park, Idylwood Park, and various private areas.

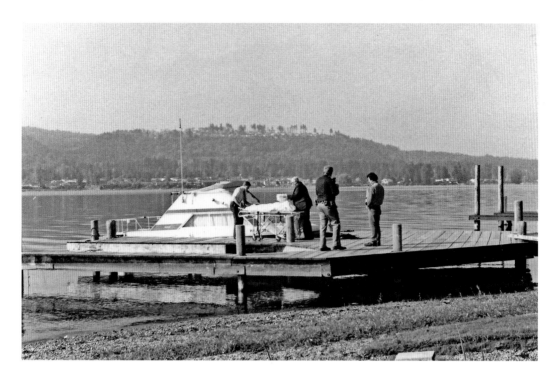

DEATH IN THE LAKE: Bill Flintoft, King County Deputy Coroner and deputy health registrar for many years, second from the left, and three others transport a body from a boat after being found in Lake Sammamish, *c.* 1960–70. Lakes and water sport are sometimes dangerous, and most of the deaths associated with Lake Sammamish are drowning. *(Issaquah History Museums, 2004.039.331)* Most of the deaths in the lake are still associated with drowning. A new boat launch was built and opened at Sammamish Landing off East Lake Sammamish Parkway in 2013.

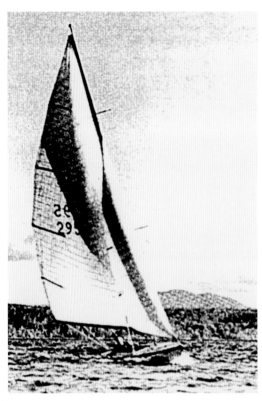

SAILING: The only known sailboat racing group on Lake Sammamish was the Sammamish Six S Fleet. The Six Star Class boats raced every weekend, c.1963–67. A new sailing course was laid out for each race. (*From the collections of Redmond Historical Society*) Sailboats are still popular on Lake Sammamish, especially on sunny days. Today the Lake Sammamish Yacht Club, founded in 2004, is open to any local boaters interested in social events on the lake.

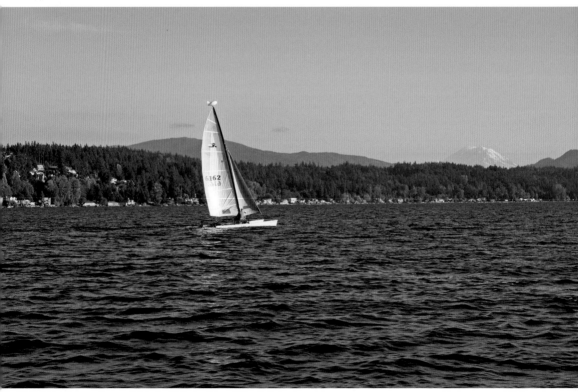

FISHING: Ai Garner and Reada Lewis huddle for warmth on a fishing trip at Lake Sammamish, *c.* 1970–1983. (*Issaquah History Museums, 2001.007.011*) Fishing is still popular during all months on Lake Sammamish. Fishermen cast for wild coastal cutthroat trout, smallmouth bass and yellow perch are favorites. This man patiently waits for fish in the fall weather, off of Idylwood pier, Idylwood Park in Redmond.

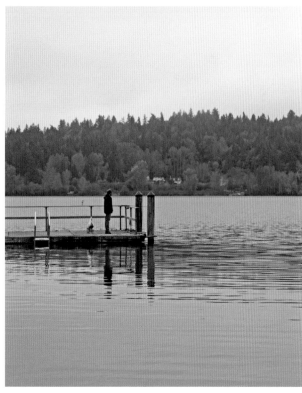

Local history is not just about the places we live. It is about the people who lived in those places, and how their lives have changed today's geography. Local history is not about the history of Great Men, but about the Common Man who, through his actions, changes the landscape.

When I first moved back to the west coast from the east coast, I was amazed by how hidden history seemed – initially. But it does not take long to see that the industry and activities once prominent on Lake Sammamish, did leave a trace. The people that planed logs, drove boats, and skied, participated in changing the landscape.

There are several important institutions and individuals that have been instrumental in completing this book: University of Washington Libraries Special Collections; Museum of History & Industry; Sarah Frederick, Collections Manager, Eastside Heritage Center; Julia Belgrave, Archives Specialist, Issaquah History Museums; Laura Hall, Administrative Coordinator, Issaquah History Museums; Julie Hunter, Collections Manager, Issaquah History Museums; Lissa Kramer, Programs Coordinator, Issaquah History Museums; Erica Maniez, Museum Director, Issaquah History Museums; Monica Park, Curator, Redmond Historical Society; Walt & Rosemary Carrel, Sammamish Heritage Society; Selitrennikoff Family, Johnson Family; and the Sammamish Rowing Association.

A special thanks to my family and friends for being a sounding board throughout the process, and to my husband, for being transportation for tricky photographs.